Pen & Ink
SKETCHING

PETER CALDWELL

B.T. Batsford Ltd, London

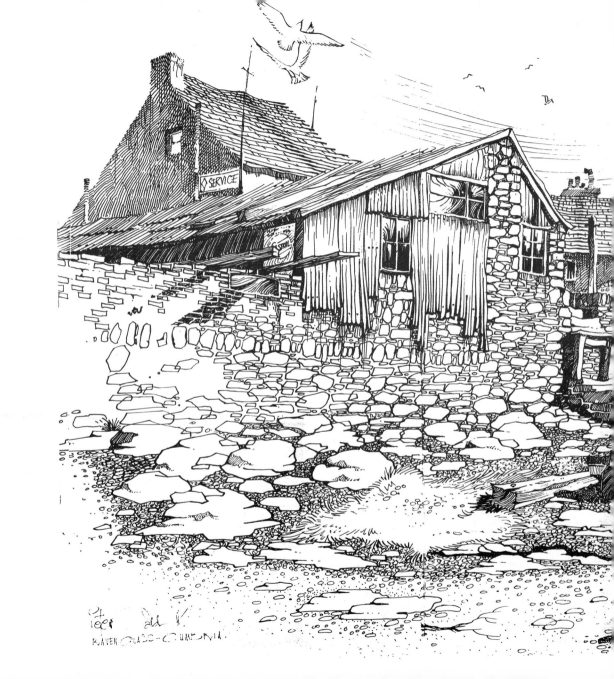

Cumbrian coast.
Dip pen and ink on buff paper,
580 mm × 295 mm

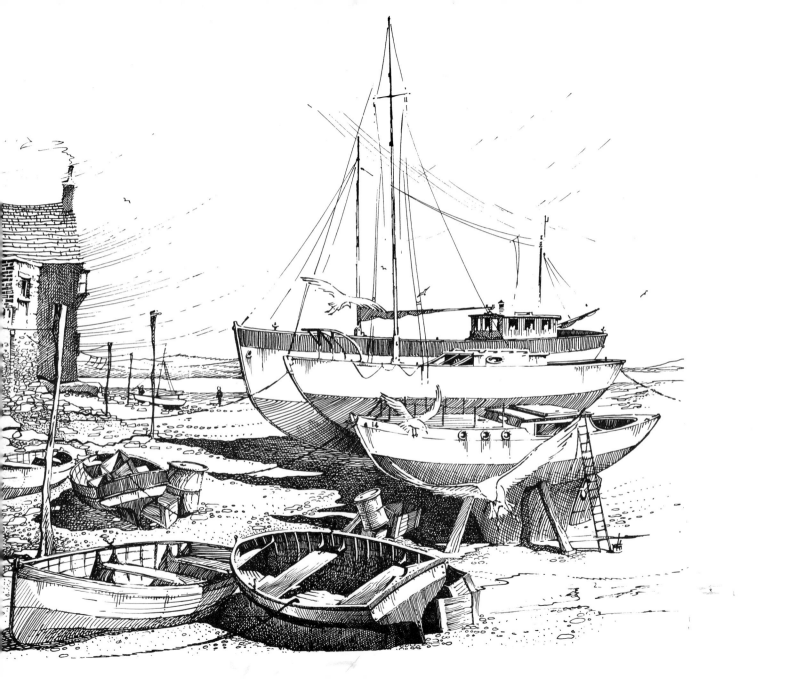

First published 1993

First published in paperback 1995

Reprinted 1996

© Peter Caldwell 1993

British Library Cataloguing-in-Publication Data.
A catalogue record for this book is available
from the British Library.

ISBN 0 7134 7909 4

Typeset by Lasertext Limited, Stretford

Printed in Great Britain by
The Bath Press Ltd
Avon

For the publisher
B.T. Batsford Ltd
4 Fitzhardinge Street
London W1H 0AH

CONTENTS

For Kath

INTRODUCTION

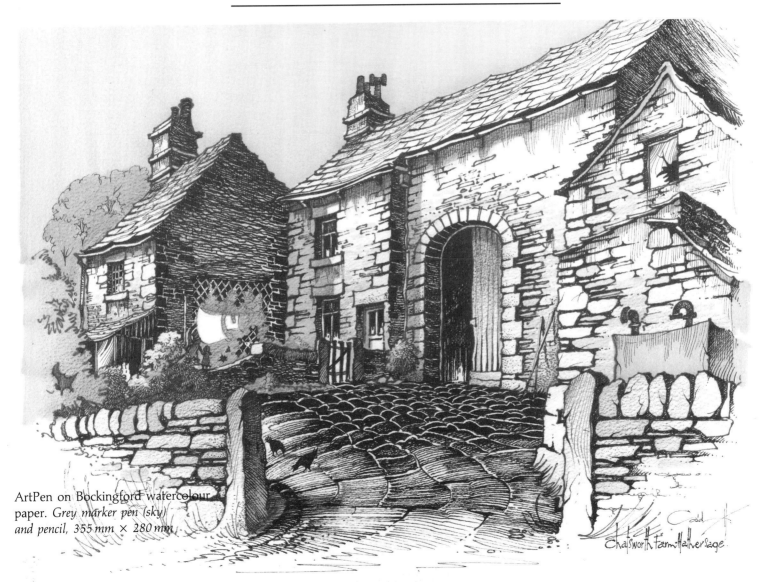

ArtPen on Bockingford watercolour
paper. *Grey marker pen (sky)
and pencil, 355 mm × 280 mm*

Chatsworth Farm Hathersage

I started drawing 'seriously' when I was about fifteen years old, which coincided with the acquisition of my first long-distance touring bike. This had drop handlebars, dérailleur gears and panniers which held just about anything and everything, including a sketchbook and pencils, plus a bottle of Indian ink and pens. My exploration of Britain had started! I had transport and, although I would have liked a camera to record my journeys, the fact was that I couldn't afford one at the time, so I was obliged to resort to drawing my favourite places. Looking back, I am very thankful that I hadn't the ready finance to buy a camera; who knows, my career might have taken a completely different course! As things turned out, it was the best grounding I could have had, with wonderful days of pedalling and sketching.

My idol during this growing-up and learning period of my life was the great pen-and-ink artist, Frank Patterson, who will be fondly remembered by many people of my own age. His work appeared regularly in travel features and all sorts of periodicals, including *Cycling* magazine, and I am not ashamed to admit how much I tried to emulate this man's genius.

In any job or creative activity, a passion for the subject is half the battle to achieving success. Without this whole-hearted desire to interpret what you see with love and sensitivity, the whole process of drawing is merely a mechanical exercise. There is a lot to be said for a quick sketch – however crude and lacking the authority of the professional's hand – if it is carried out with sincerity and commitment. Style is something that cannot be hurried; it happens quite naturally with practice, in much the same way that handwriting develops and matures with constant use.

In my own case, after many years of sketching and drawing, it was my friends who pointed out to me how they could recognize my work from that of other artists – not necessarily because it was any worse or better, but, simply, because I had developed my own distinctive way, or style, of drawing. The lesson here is not consciously to develop a style but, rather, to allow it to happen with time and practice. The result will eventually become the hallmark of your work, recognizable at a glance. Forcing a style, on the other hand, will look contrived.

I feel I must make a mention, in this brief introduction, to the wonderful benefits of drawing out of doors, given that you have the desire and courage to work under the public gaze. I can remember vividly the many times, early in my career, when I was working on some busy street corner trying desperately to appear nonchalantly professional, while inwardly feeling terribly inhibited, and extremely aware of prying eyes and whispered comments. In reality, of course, people aren't trying to put you off or hinder your work and, in the main, are only as interested as you would be if you saw someone else sketching. I can only reassure you that in time these inhibitions do disappear as you become better at drawing. In fact, I have had many interesting chats with passers-by, and even been offered tea and coffee. I have certainly made many new and rewarding friendships while drawing outdoors on a sunny day.

Apart from these benefits, the whole idea of getting out and about, and actually confronting the subject, is very exciting. The adrenalin certainly flows more freely than when one is sitting in one's studio. The finished effect of a drawing made out of doors will be most apparent when compared with a piece of work completed indoors. The outdoor sketch will have a wonderful sense of

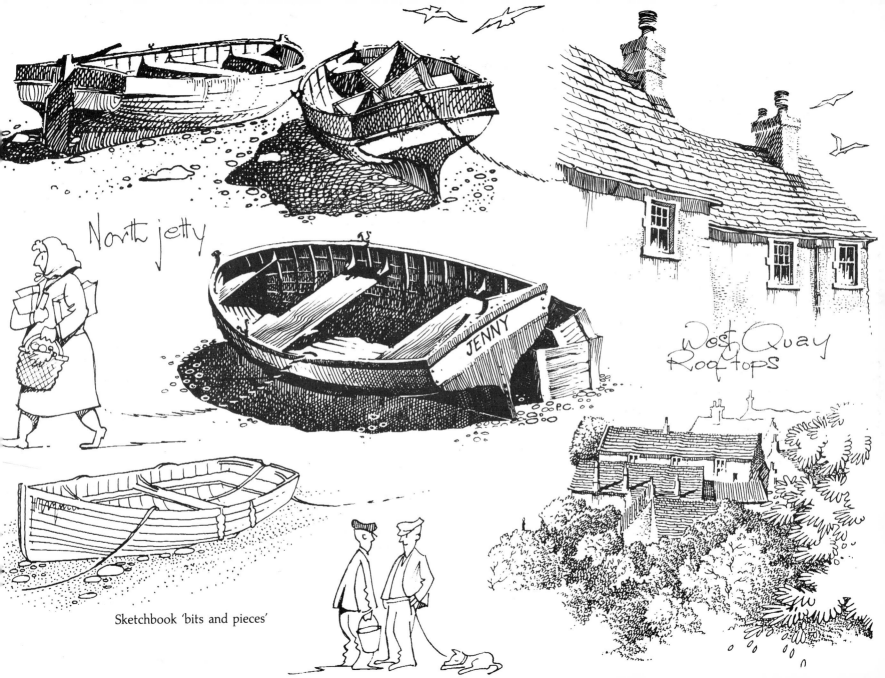

North jetty

JENNY

West Quay Rooftops

Sketchbook 'bits and pieces'

immediacy, or spontaneity, seldom achieved in the relative comfort of 'armchair art' with time to spare. There is nothing wrong with warmth and comfort, of course, but do get out whenever possible – it is well worth the effort!

The beauty of pen-and-ink drawing is that it is a medium complete in itself, and does not rely on anything else – such as colour, crayon, pencil, and so on – to enhance or embellish the final picture. A well-executed pen drawing is a thing of great beauty and has its own useful niche in the world of art. Having heaped all this praise on black-ink line drawings, I am also keen to use pen and ink in conjunction with other mixed media. Ink-rendering lives very happily with chalk, pastel, markers, gouache, conté and particularly watercolour washes. Ink also lends itself to all sorts of experimentation, and as a change from the conventional pen I have used matchsticks, twigs, sponges, quills, bamboo, brushes of all descriptions and even the thin edge of an old plastic credit card in my work.

Just wandering into any art shop whets my appetite to draw. I feel like a child let loose in an Aladdin's cave full of materials and gadgets, particularly with the wealth of pens now available. I'm afraid that I can't resist the temptation to buy any new line in pens! Such is the variety on offer that the best advice I can give you is to buy those with which you feel happiest; this may be because of the nib, the way the ink flows, or even the way the pen fits snugly in your hand. All these things have to be considered, and I shall endeavour to nudge you gently in the right direction as you read on.

Outdoor sketching requires just the right amount of gear – no more, no less. Try to be compact and comfortable. Too much equipment to drag around is as bad as too little!

EQUIPMENT

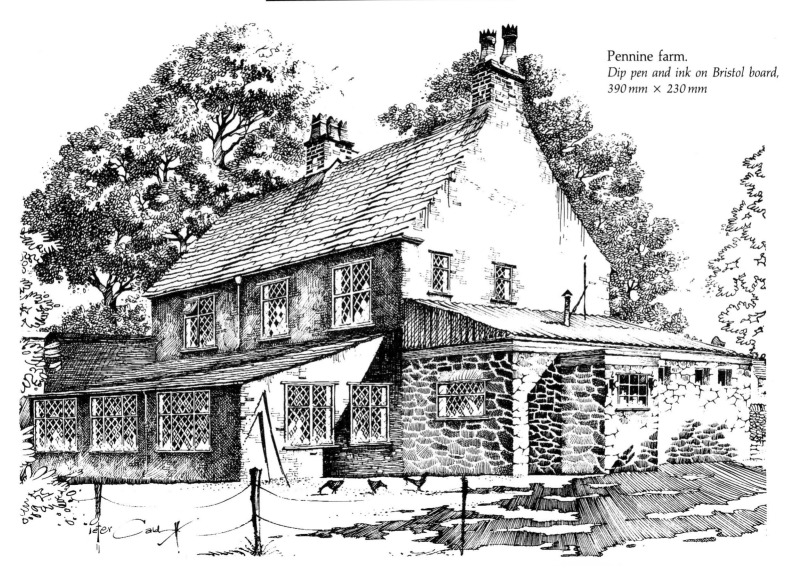

Pennine farm.
*Dip pen and ink on Bristol board,
390 mm × 230 mm*

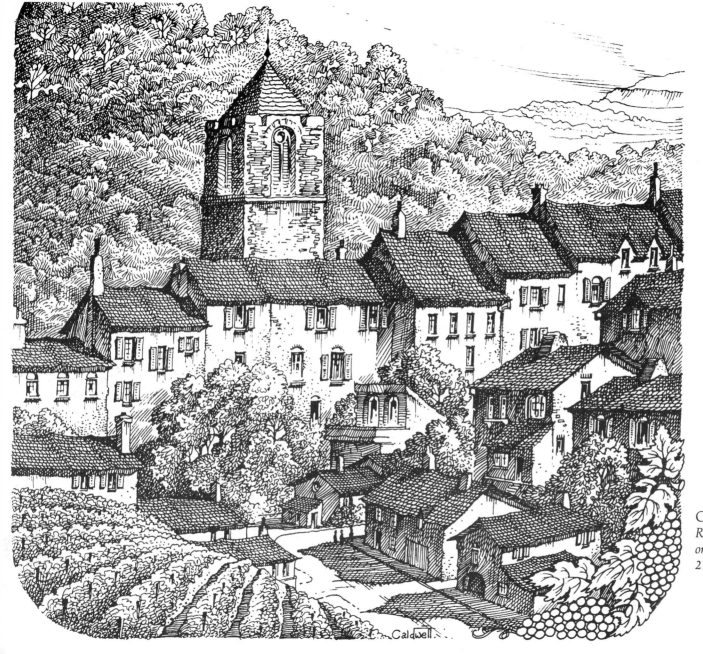

Ollières, France.
Rapidograph needlepoint pen on cartridge paper,
215 mm × 215 mm

What could be simpler for pen-and-ink drawing than just to recommend a bottle of Indian ink, a dip pen and a smooth-cartridge-paper sketchbook? If I were to do so, this would be the shortest chapter on record. Even though these few items do form the basis for getting started, there are also many alternatives. Such is the extraordinary variety of pens and papers available to us these days that we are all quite spoilt for choice! A visit to the art shop for suitable materials can be a mind-boggling — albeit very exciting — experience if you are anything like me.

Although one can draw on many sorts of materials, with almost any tool that leaves a mark, I will give you, in the next two chapters, a fairly comprehensive list of the more sophisticated ranges of items and papers with which you could equip yourself. Even so, from my own experience, I change my allegiance to certain pens and papers from time to time as improved markers arrive on the market — it is always exciting to try out innovations. Sometimes they don't come up to expectations but, more often than not, they open up new avenues of artistic application.

Most papers and card have remained basically the same over the years. We have always had a good choice in quality and textures. One fairly minor addition to the paper range has been the introduction of recycled paper to satisfy the more environmentally-conscious among us. I tried recycled cartridge-paper sketchbooks while working in California, and found the quality excellent for pencil sketching.

The biggest improvements, and increase in variety, have been with the pen, particularly in the field of disposable products. Over the years I have successfully used all the equipment described in the following pages.

Sea shells.
Indian ink on cartridge paper, 120 mm × 135 mm

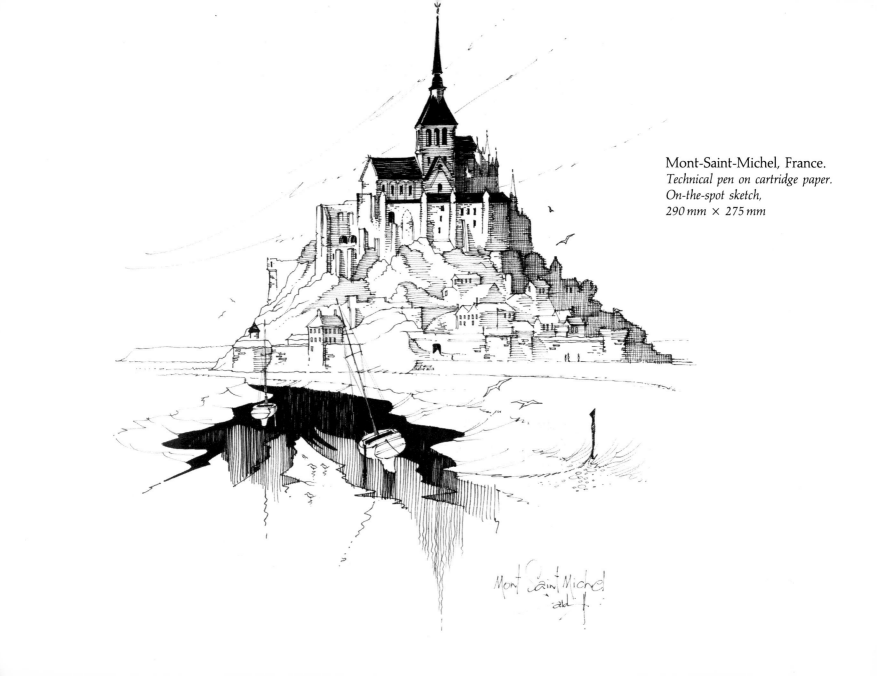

Mont-Saint-Michel, France.
Technical pen on cartridge paper.
On-the-spot sketch,
290 mm × 275 mm

WHAT TO DRAW ON

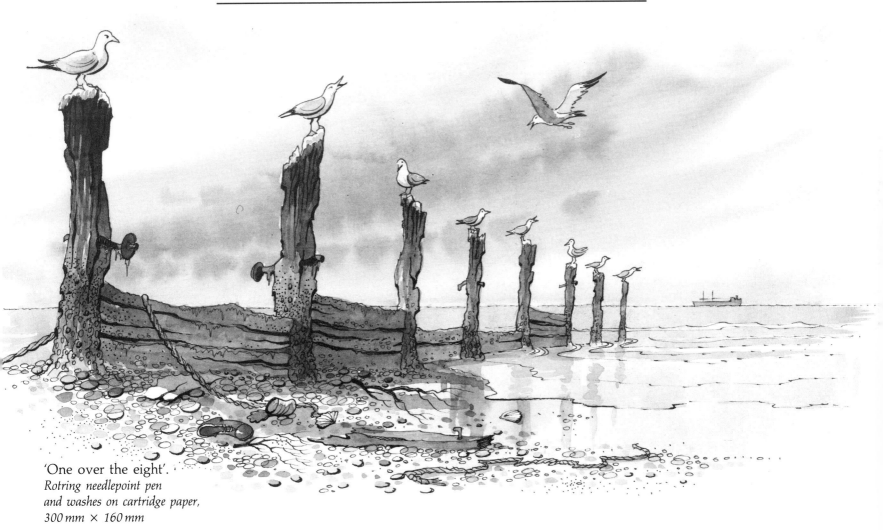

'One over the eight'.
*Rotring needlepoint pen
and washes on cartridge paper,
300 mm × 160 mm*

15

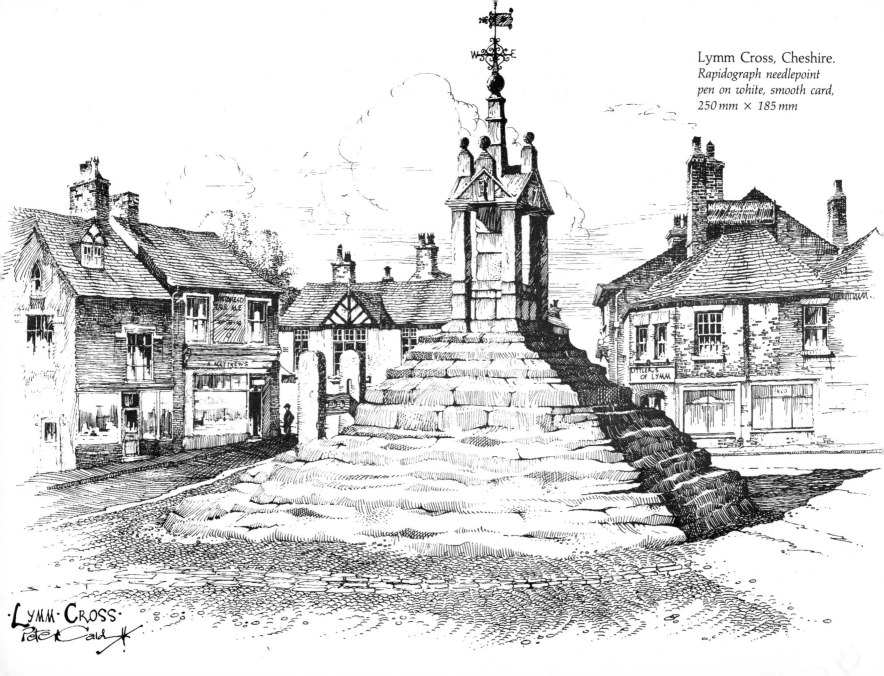

Lymm Cross, Cheshire.
*Rapidograph needlepoint
pen on white, smooth card,
250 mm × 185 mm*

Sometimes ordinary, smooth paper, meant for things other than artwork, can be as good as the more expensive lines. For example, brown or buff wrapping-paper offers a good surface for pastel and ink drawings. Writing and duplicating paper also has an excellent surface for pen drawings. Generally speaking, however, the use of specially prepared art paper will guarantee the durability of the finished work.

BRISTOL BOARD

This is an ultra-smooth, hard, white board available in various thicknesses (one sheet thick, two sheet, three sheet and so on). Even though ink drawings can be carried out on most papers, Bristol board is the supreme surface for pen-and-ink. The one-sheet thickness is about the same weight as this page, and the paper increases in thickness to the point at which you can obtain quite a stiff board, with the surface quality remaining the same. I use a two- or three-sheet thickness by choice.

CARTRIDGE PAPER

Also called Ledger Bond, this is the most popular and commonly used drawing-paper. It is available in a variety of surfaces: smooth, 'Not' (semi-rough) and rough. 'Not' simply means that the paper is not 'hot-pressed' (smooth surfaces are hot-pressed during manufacture). Cartridge paper will take ink work, and has the added advantage of taking kindly to tonal washes and watercolour.

INGRES PAPER

This is manufactured mainly for pastel drawings. It has a soft, furry surface and is available in a variety of colours, such as grey, pink, blue, buff, and so on. It is obtainable in single sheets or in sketchbook form. It is worth mentioning that, although Ingres is primarily a pastel paper, it will take ink applied carefully with a brush or pen (any over-vigorous use with a pen can dig into the surface). Having said this, I do like to use mixed media on light-tinted Ingres: i.e., watercolour and ink, pastel and ink, gouache and ink, or a combination of all these media.

There is a wide range of other tinted papers on the market too, many of which are suitable for pen-and-ink work. As you gain experience and confidence you will be able to gauge their suitability, and manufacturers are usually happy to provide samples.

WATERCOLOUR PAPER

This comes in all shapes and sizes, including sheets, pads, blocks and spiral-bound books. Each manufacturer supplies a wide range of textures and grainy surfaces, and these are all a matter of personal choice.

All watercolour papers are classified by weight, from the lightest, at 70 lb (150 gsm), to the heaviest, at 400 lb (850 gsm). I like to use papers in the middle-weight range of 120–200 lb (255–425 gsm) as these can stand a lot of wetting without crinkling or cockling. I find that the thinner, less heavy papers do not keep their shape under the onslaught of my 'wet-in-wet' tonal washes. For commercial work I will sometimes use a sheet of Daler 'Not' watercolour board, which gives me everything I need for a nice 'broken' ink line drawing, with additional loose washes. Watercolour paper comes in various finishes: smooth, rag and rough ('Not').

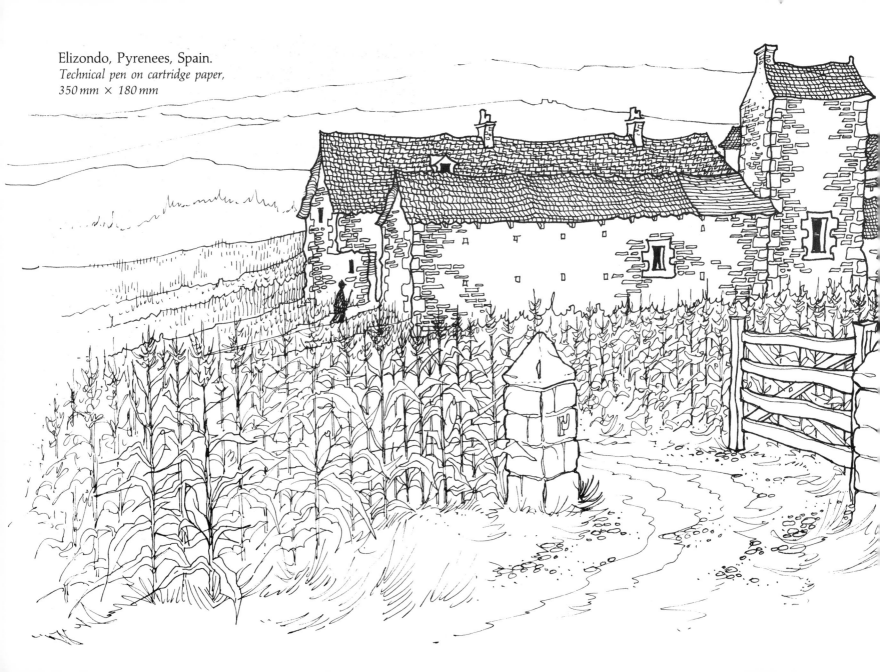

Elizondo, Pyrenees, Spain.
Technical pen on cartridge paper,
350 mm × 180 mm

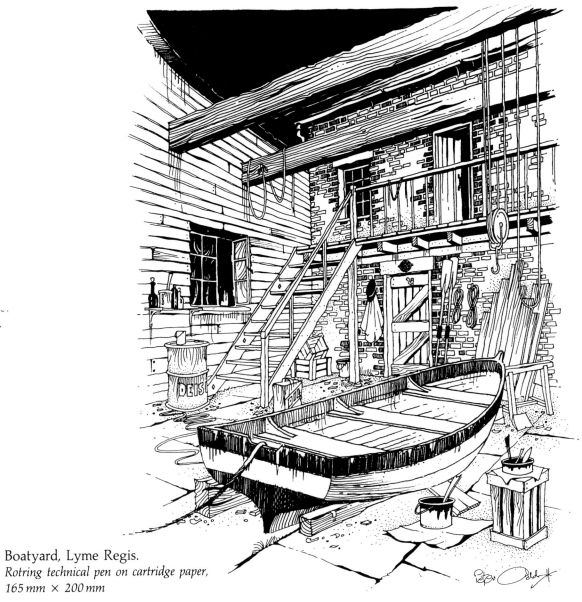

Boatyard, Lyme Regis.
Rotring technical pen on cartridge paper,
165 mm × 200 mm

19

WHAT TO DRAW WITH

Courtyard.
Technical pen on cartridge board,
140 mm × 170 mm

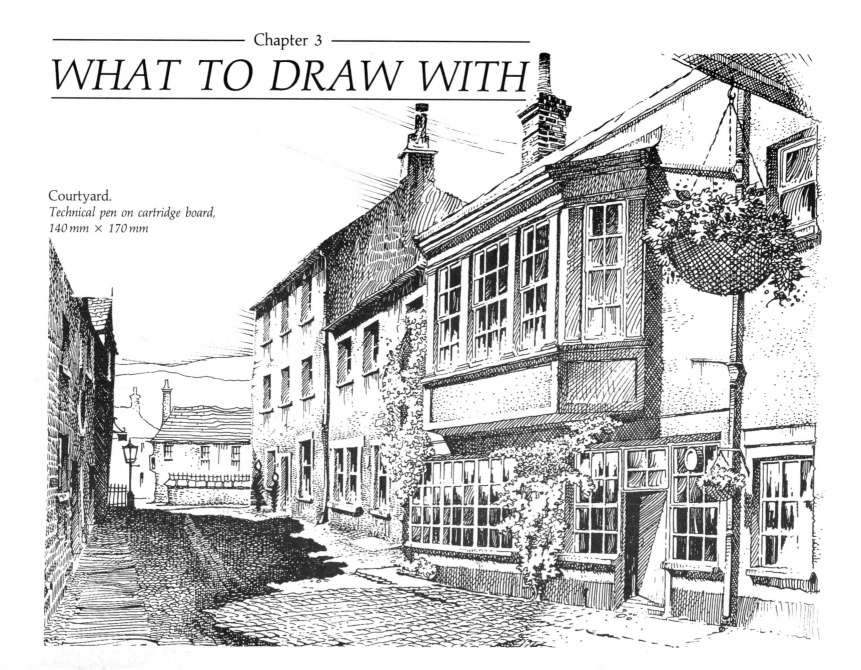

Of all the multitudinous new products flooding the market, pencils and pens are the most prolific and innovative. How many ways can nibs be held in place, in what is only a 'holder' after all? In saying this, I know that I am being rather simplistic, based, no doubt, on the fact that I was introduced to pen drawing when the ultimate tool for the job was a nib stuck into a wooden holder! This, in turn, necessitated constantly dipping into a bottle of Indian ink – hence the name 'dip pen'. Of course, one could change the nib to suit the artwork in hand, choosing an ultra-fine point (mapping nib), or fine, medium or broad nibs.

The beauty of a dip-pen nib is its great flexibility, responding to whatever pressure you care to put on it to give a line of varying intensity and thickness. Crude and unsophisticated as this pen is, in my opinion the nib itself has never been improved upon for versatility. In lieu of this, however, we do have a greater choice of pens, each with its own claim to fame: cartridge-ink feeds which do not require dipping; improved holders with non-slip grips; various sizes

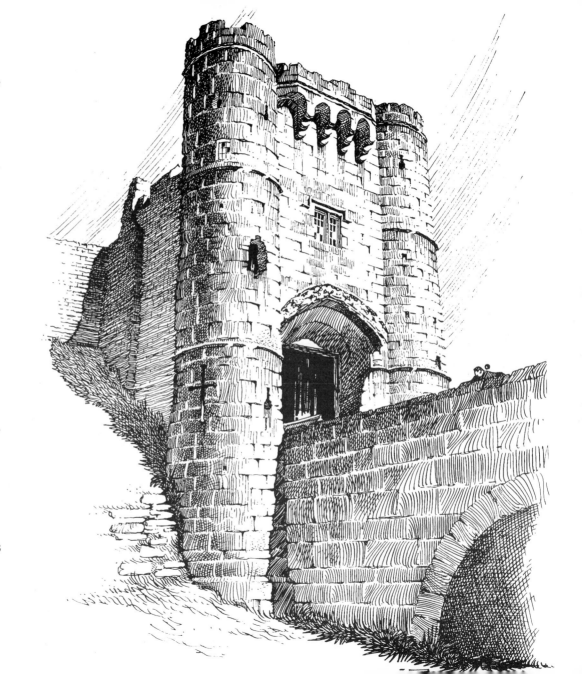

Carisbrooke Castle, Isle of Wight.
Dip pen on Bristol board,
190 mm × 245 mm

of needle-point nibs for uniformity of smooth lines; fountain-pen nibs with cartridges for black or coloured inks – the list is endless. The following are some of those that I have tried and tested with success.

INKS

Ink is the most basic and important item of your equipment. You must consider your choice of ink carefully, because it will make or break the effect you are striving for in your drawing. Inks vary considerably: there is an excellent colour range, although the most commonly used colours for pen-and-ink work are black or dark brown.

The biggest decision you will have to make is whether the ink has to be waterproof or water-soluble. If your drawing is going to be purely and simply pen-and-ink, without any washes over it, then it doesn't matter which ink you use. If your final pen drawing is to have tonal or watercolour washes brushed on, however, then a waterproof ink is imperative, or it will run into the wash, with disastrous effects! Most of the disposable pens on the market, with their ink contents sealed in, are clearly marked whether they are waterproof. Likewise, most ink cartridges, which fit into a permanent holder, are water-soluble. The simple answer, if you are

not sure, is to test the pen in the art shop — scribble a few lines, allow the ink to dry properly, and then rub a wet finger through it.

A final note about inks: you can mix water with any ink in order to make it thinner, should you wish to brush it on to your drawing in different tones. If you are using Indian ink, however, add distilled water or rainwater, as ordinary water will cause the ink to curdle.

DIP PENS

I have already touched upon these at the beginning of this chapter. As the name implies, these are nibs inserted into simple holders and dipped into Indian ink. I usually use Gillott 303 and 404 nibs, which are extremely flexible and, depending upon the pressure put on them, will produce very fine lines through to quite thick strokes. Guard the nibs by carrying the pens in an aluminium cigar holder or similar container.

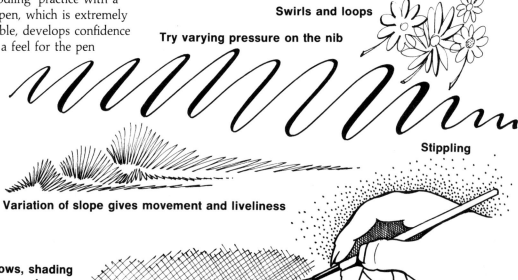

'Doodling' practice with a dip pen, which is extremely flexible, develops confidence and a feel for the pen

Swirls and loops

Try varying pressure on the nib

Stippling

Variation of slope gives movement and liveliness

Shadows, shading and tone rely on cross-hatching, although stippling (or a combination of both) can achieve the same effect

Keep your hand firmly on the paper like an anchor, using swirling, flexible finger movements

FOUNTAIN PENS

These have a much softer touch than dip-in pens, and many artists prefer them. The main advantage is that the barrel can be filled with certain specially prepared Indian inks, which will not cause clogging. Alternatively, some can be filled by the insertion of an ink cartridge. Some fountain pens have a springy, flexible nib, and my favourite, which I have used for many years, is the ArtPen. Again, depending on your requirements, do check whether the inks are marked as waterproof or water-soluble.

Special fountain pens (such as Rapidograph and Rotring) control the flow of ink by means of a needle valve in a 'fine-tube' nib. Nibs are available in several grades of fineness and are inter-changeable. The line they produce is of even thickness, but on coarse paper they enable you to draw an interesting broken line. These 'fine-tube' nib pens must be held at a right angle to the paper to operate efficiently, and are often called 'technical' pens. They contain cartridges which can be refilled with specially prepared waterproof ink.

REED, BAMBOO AND QUILL PENS

These are fun to use and exciting for large, bold line drawings. You can make the nib end narrower or wider with the help of a sharp knife or razor blade.

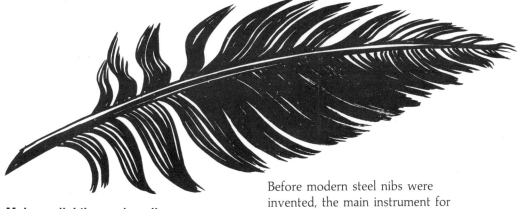

Make a slightly curving slice, then cut the tip to the desired width

Carefully split the tip about 6 to 9 mm

FIBRE- AND FELT-TIPPED PENS

These are extremely easy tools to use. Choose from among the many varieties now on the market according to what feels right for you to hold. Fibre- and felt-tips also come in a range of thicknesses.

Finished sketches can be enhanced by conté crayon or pastels, or by brushing

A quill is cheap, always available and very effective – the original disposable pen. I used a seagull feather to draw this quill pen. The lines can be thick or thin, according to how sharp the end is cut

Before modern steel nibs were invented, the main instrument for writing and decorative drawing was the quill pen

a watercolour wash into some areas. A word of warning: most felt-tipped pens are acid-based and make a strong line or mark which can spread slightly on certain porous papers. You may like this spreading effect, however, as it can soften otherwise hard lines. A watercolour wash will go over most felt lines, but fibre-tipped pens are mainly

Felt-tipped-pen sketch
of a boat on water
with reflections

water-based, and therefore soluble. Clean water applied with a brush over certain areas gives a good effect, as you can see in the boat sketch below. The technique is simply to brush on the water and let the lines 'melt away' of their own accord.

BRUSHES

Brushes are the most versatile drawing, as well as painting, instruments. The biggest sable brush has a fine point, while the smallest brush, laid on its side, provides a line broader than the broadest nib. A particularly attractive texture that the brush provides is that of the dry-brush effect. To elaborate

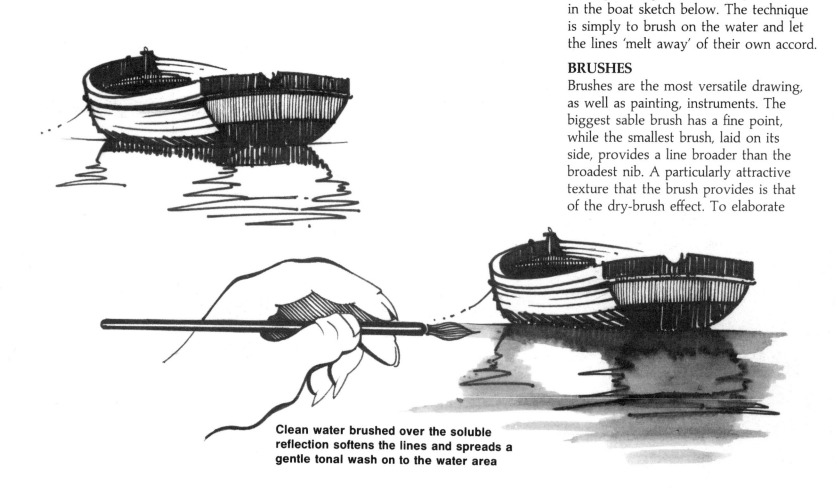

**Clean water brushed over the soluble
reflection softens the lines and spreads a
gentle tonal wash on to the water area**

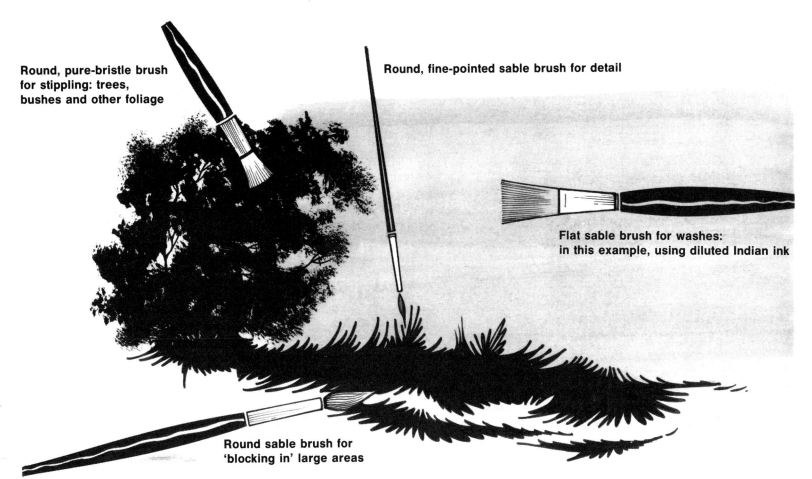

Round, pure-bristle brush for stippling: trees, bushes and other foliage

Round, fine-pointed sable brush for detail

Flat sable brush for washes: in this example, using diluted Indian ink

Round sable brush for 'blocking in' large areas

on this: when the brush is only half-full of ink, it can be dragged across the paper until it loses its ink. This provides a broken texture for areas such as the surface of water, or a large expanse of meadow. This illustration shows the brushes available, and what they can do.

Different brushes are used to create a range of effects

25

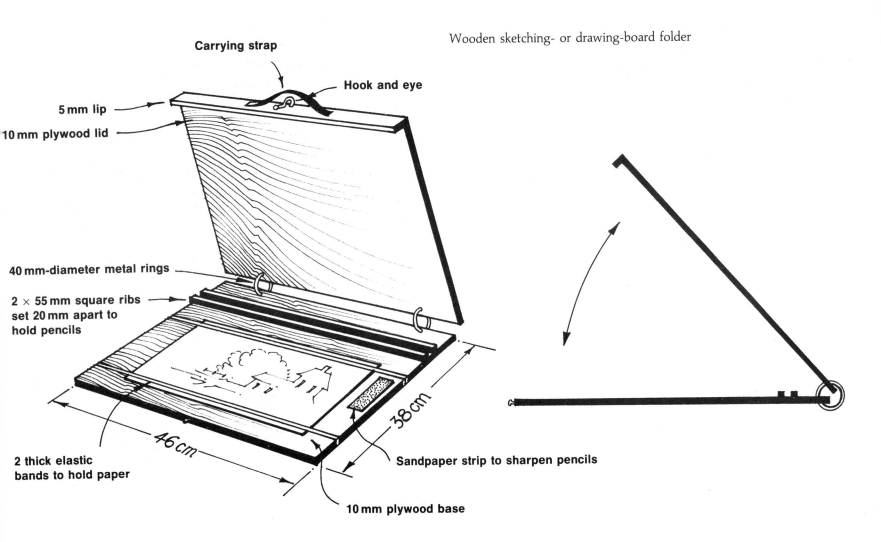

Carrying strap

Hook and eye

Wooden sketching- or drawing-board folder

5 mm lip

10 mm plywood lid

40 mm-diameter metal rings

2 × 55 mm square ribs set 20 mm apart to hold pencils

2 thick elastic bands to hold paper

46 cm

38 cm

Sandpaper strip to sharpen pencils

10 mm plywood base

WOODEN SKETCHING FOLDER

I cannot let this chapter pass by without bringing to your attention a piece of equipment which I made for myself (see opposite). It goes everywhere with me – in fact, I don't know what I did before I had this idea to protect my work from the elements! The advantages of such a wooden sketching folder must be obvious. As well as acting as a small drawing-board, it hinges together like a book binder and secures the work from knocks, scrapes and rain when it is being carried around.

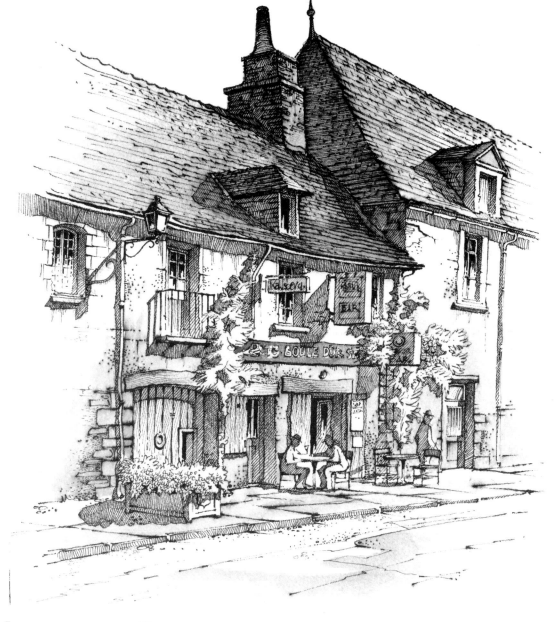

Richelieu, France.
Technical pen and washes
on Bockingford rough-surface board,
300 mm × 260 mm

MAKING A START

Having sorted out our equipment, we cannot just dive into the deep end by tackling a subject which requires a great degree of expertise; first, we must become used to the tools. I always like to think that learning to draw, particularly with unfamiliar materials, is rather like learning to drive a car, with three phases of progression. First of all you need to know how to use the basic equipment; then you have to go through the sometimes agonizing business of constant practice, trying to get accustomed to which item does what; and finally, as with driving a car, you realize that gradually you are doing things quite naturally, without thinking too much about them. Consequently, you are more relaxed and simply enjoy the experience of driving, or drawing, as the case may be.

The ability to draw exists in all of us, to a greater or lesser degree – remember that before mankind learned to write, speech and drawing were the only means of communication. With a little guidance, as well as perseverance, we are bound to improve. How much

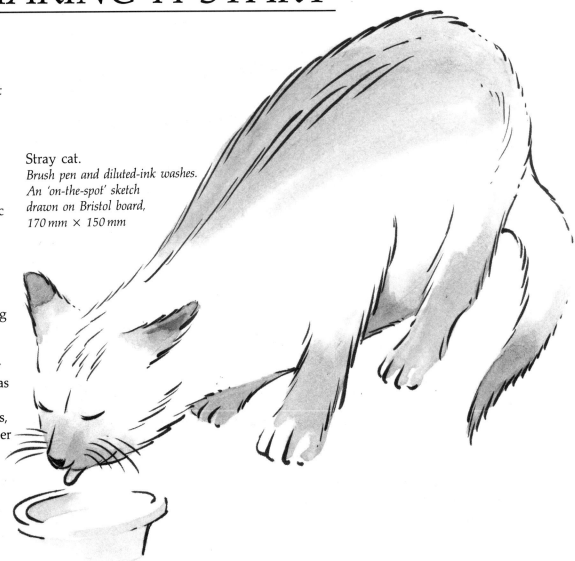

Stray cat.
Brush pen and diluted-ink washes.
An 'on-the-spot' sketch
drawn on Bristol board,
170 mm × 150 mm

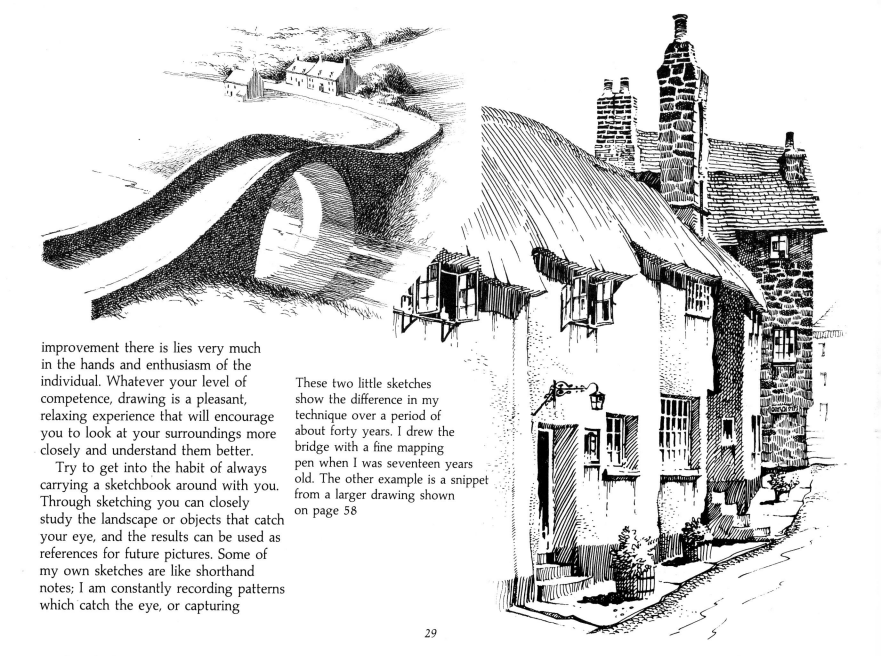

improvement there is lies very much in the hands and enthusiasm of the individual. Whatever your level of competence, drawing is a pleasant, relaxing experience that will encourage you to look at your surroundings more closely and understand them better.

Try to get into the habit of always carrying a sketchbook around with you. Through sketching you can closely study the landscape or objects that catch your eye, and the results can be used as references for future pictures. Some of my own sketches are like shorthand notes; I am constantly recording patterns which catch the eye, or capturing

These two little sketches show the difference in my technique over a period of about forty years. I drew the bridge with a fine mapping pen when I was seventeen years old. The other example is a snippet from a larger drawing shown on page 58

29

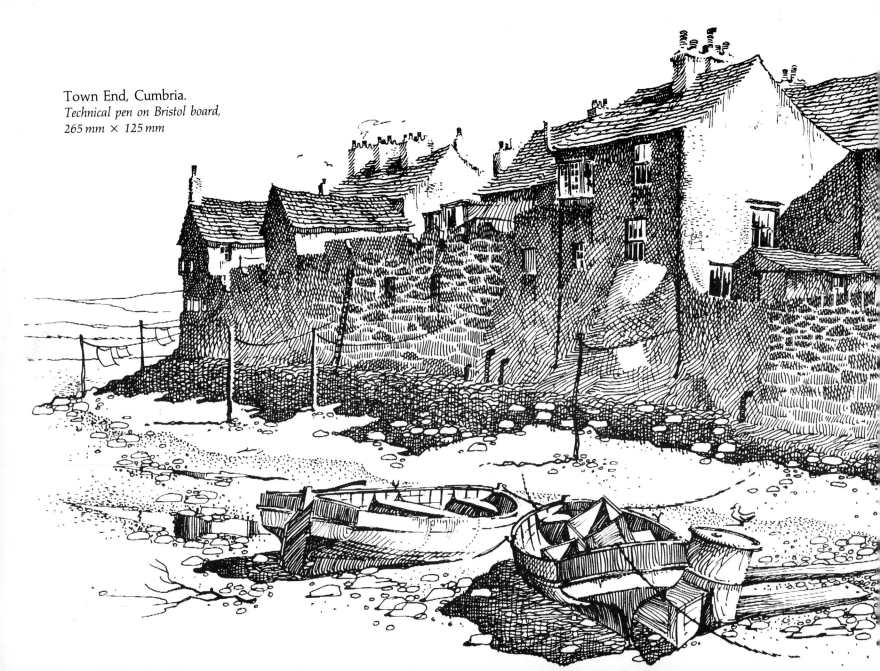

Town End, Cumbria.
Technical pen on Bristol board,
265 mm × 125 mm

fleeting tricks of the light. Once again, I would like to dispel any worries you may have about developing a personal style in your art. Like it or not, a certain style does emerge in most artists' work in the fullness of time and practice. It won't appear by magic overnight, and trying to contrive a hallmark, or even copying another artist's recognized style, will only be short-lived. In either case, it would only be rather like sublimating your own natural way of working with a false veneer.

Just as handwriting distinguishes one person's script from another, it is very rare indeed to find two artists with the same style. I think the analogy with handwriting is a good one: no two people write in exactly the same way. We might start off trying to copy or imitate a particular artist's technique, but, as time goes by and progress is made, our own characteristics begin to creep in. So we, in turn, develop a style and technique of our own. How often do we think about our style of writing, having required the necessary ability? Seldom, if at all! We just concentrate on the message or, if we are drawing, on the subject to be drawn.

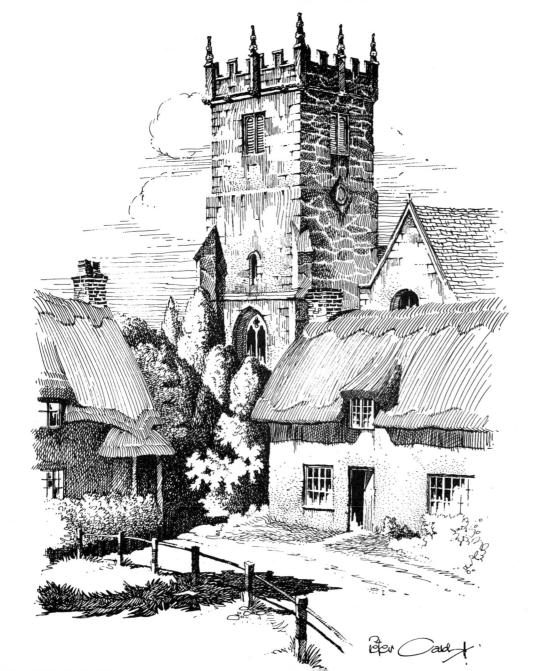

Godshill, Isle of Wight.
*Dip pen on cartridge paper,
200 mm × 260 mm*

USING THE IMAGINATION

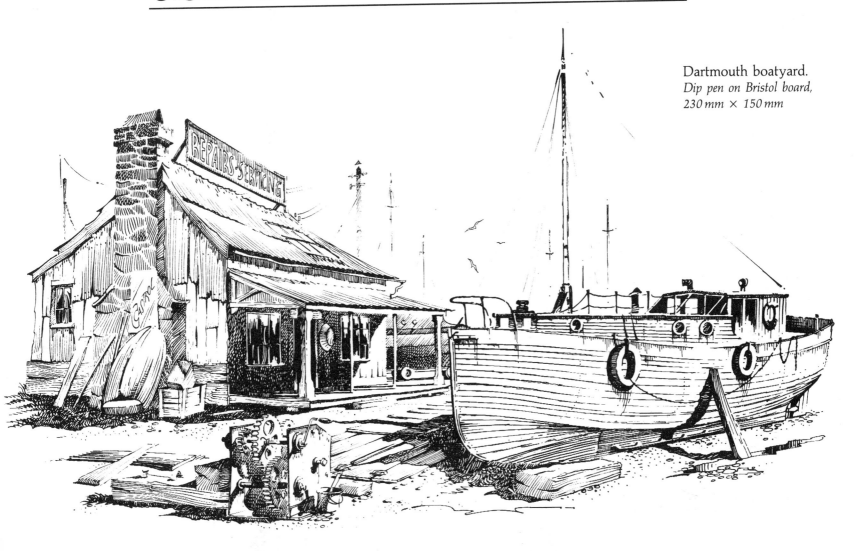

Dartmouth boatyard.
*Dip pen on Bristol board,
230 mm × 150 mm*

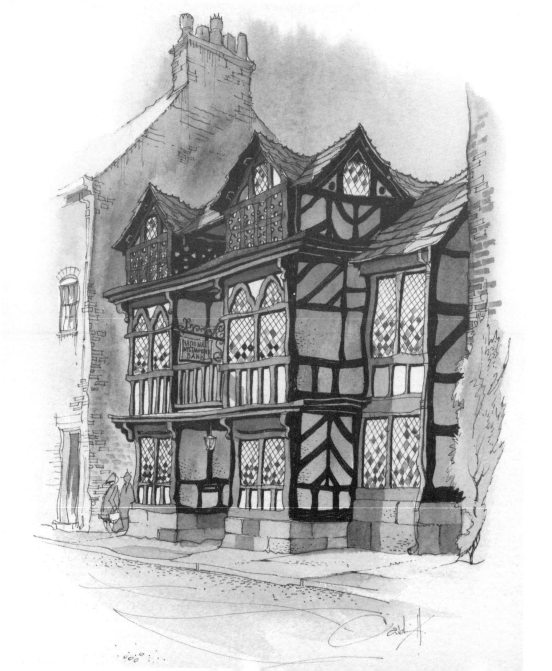

Over the years most of us have been to exhibitions and browsed our way through galleries; and, if you are anything like me, you will probably carefully examine the pictures in other people's homes before anything else! Quite often the choice of art hanging on the wall can tell you a lot about the owner's general character, and their taste in other areas.

There are numerous reasons why some pictures have appeal, while others leave one feeling completely unmoved. Differences in technique, composition, or even choice of subject, can either excite you or have the opposite effect. The old maxim, 'It's not what you do but the way that you do it' is so true!

Prestbury, Cheshire.
Technical pen and tonal washes on Bockingford rough paper, 155 mm × 210 mm

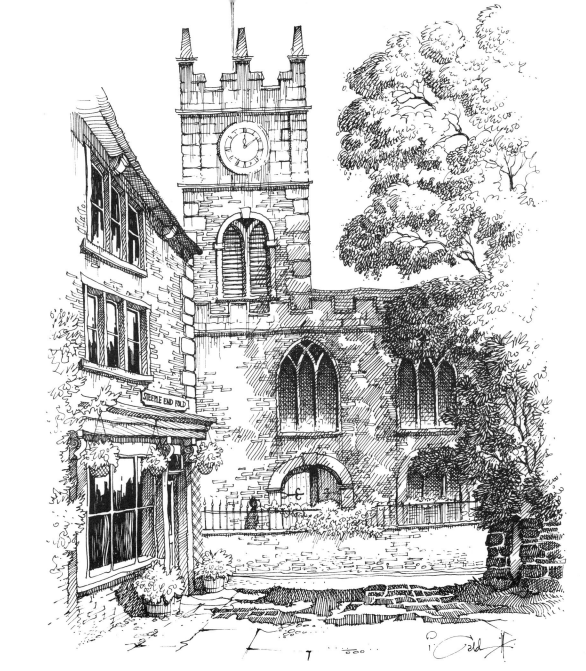

Steeple-end Fold, Hayfield.
Dip pen on smooth cartridge paper,
155 mm × 200 mm

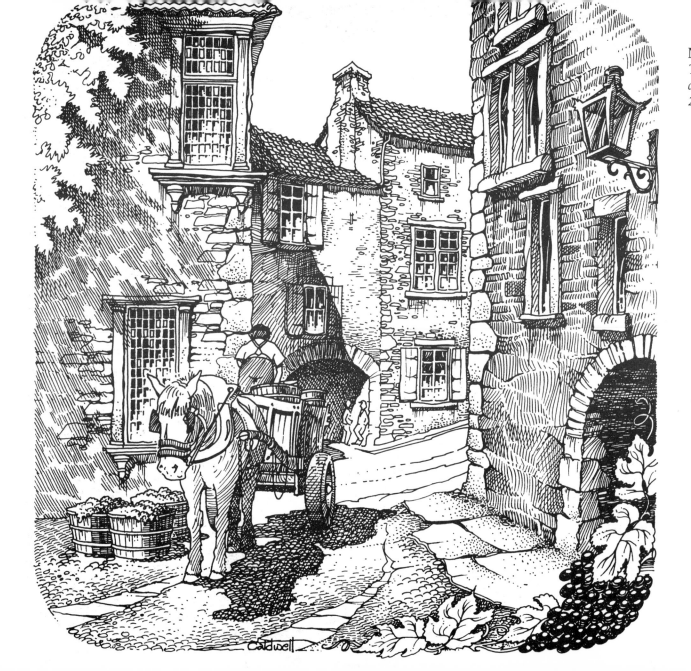

Minerve, France.
Technical pen on smooth cartridge paper,
215 mm × 215 mm

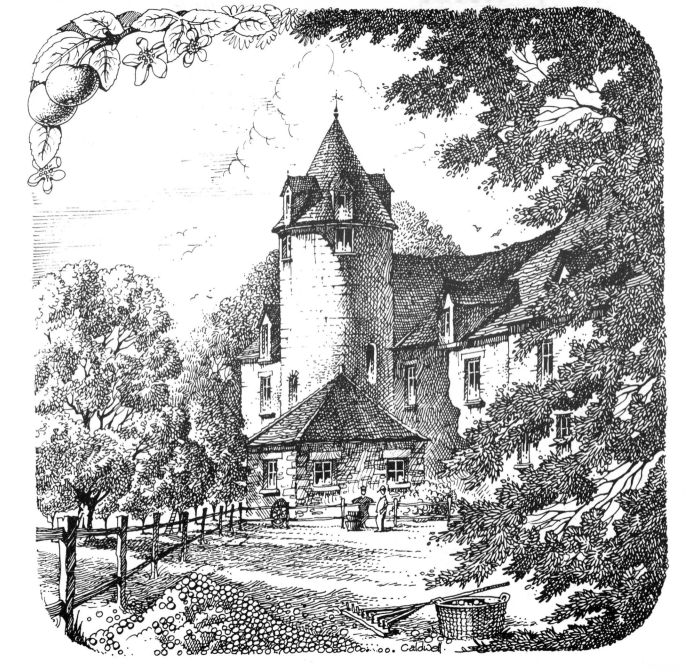

St Fraimbault, France.
Technical pen on smooth cartridge paper,
215 mm × 215 mm

It is my considered opinion, however, that the most important quality of any work of art is its ability to provoke the observer's imagination. Many people do not even realize this aspect of their own contribution to the artist's work. Like most other emotional experiences, the *combination* of appeal and response is the crucial factor. All this is not to suggest that technique, composition, choice of subject and so on are lesser priorities — on the contrary, these have to be mastered by anyone with artistic aspirations. But having the necessary ability is not the 'be all and end all', as there is still the final matter of generating an emotional response.

There are many pictures which have appealed to me even though they may have little merit technically. Whether by accident or design, the artist has brought out a response in me and allowed me, subconsciously, to use my own imagination. In my mind I have filled in the details he or she has left out; I have felt the atmosphere created by the subject; or, maybe, wanted to walk down the street in the picture, feeling an urgent need to know what was around a mysterious corner! All these things have provoked my interest, and are food for my imagination.

On the other hand, many 'perfect' examples of an artist's skill have left me quite cold, and, having initially admired

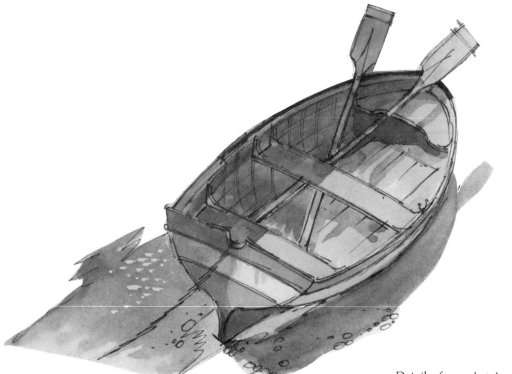

Detail of my sketch of Harry Birchenough's hut (opposite)

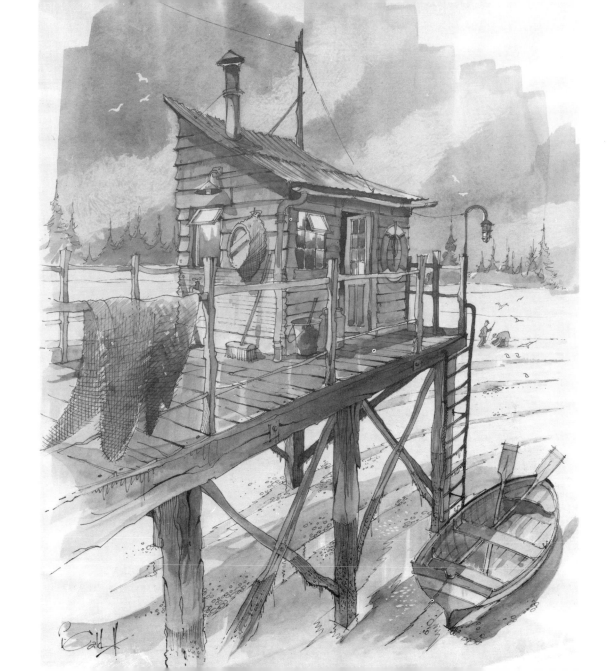

Harry Birchenough's hut,
Blakeney, Norfolk.
*Technical pen and tonal washes
on smooth cartridge paper,
290 mm × 340 mm*

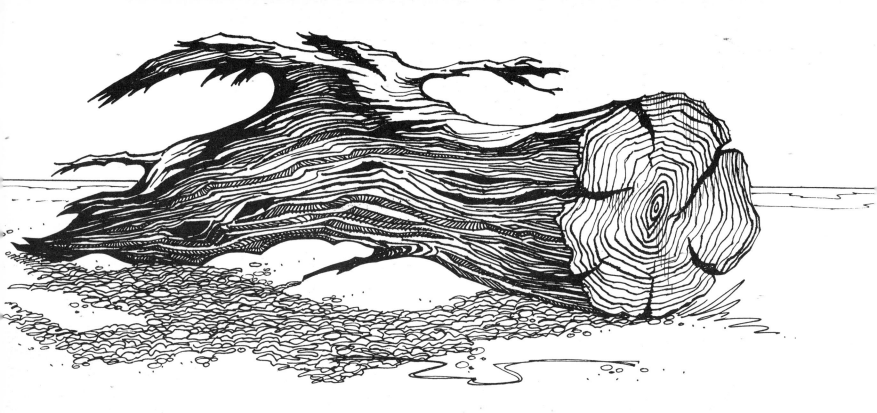

the professional dexterity, I am then bored. There has been little left for my mind to conjure with: no blurred image for me to bring into focus, no obscure shape or shadow into which I can peer. In short, my imagination has not been allowed to contribute. As with people, so in paintings, for character and individuality generate more interest than an image of perfection with sharp outlines and predictable features. The lesson to be learned here is simple in theory, but somewhat more difficult to put into practice. It is not always easy to know where to finish a picture, or to know how much to put into it, or what to leave out. Although only practice and experience can teach this lesson properly, I will make some useful suggestions in the following chapters.

Drift log.
This sketch was carried out with some improvisation. I had mislaid my pen, so I sharpened a seagull feather to a fairly fine point. In this way, nature provided me with a quill dip pen. Indian ink on Bristol board, 250 mm × 100 mm

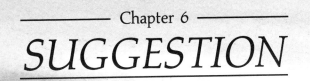

SUGGESTION

Rowarth Moor, Derbyshire.
A very simple and quick sketch, completed with the minimum of lines. This was a ten-minute atmosphere study capturing the rainswept landscape with no fussy detail. The descending cloudburst was achieved by wetting the area below the cloud and allowing the ink wash to flow freely in a downward swirl. Line and diluted-ink washes, 240 mm × 180 mm

Shire horses.
Sketches on cartridge paper

Fibre-tipped pen and technical pen

Sable brush and Indian ink

The question of how much to put into a picture and, even more importantly, how much to *leave out* always poses major problems. No matter whether one is an amateur or a professional, and working in any medium, the general tendency is to veer towards putting too much into the subject. It will probably come as a great surprise to most people to learn that leaving as much detail out as possible, without depriving the picture too much, is to be applauded.

In painting, particularly, the blurred edge to an image has far greater appeal than one which is too precise. Great precision in drawing and painting owes more to draughtsmanship than to artistic interpretation. The ability to draw accurately is not to be scorned; on the contrary, I have nothing but praise for those people blessed with such talent. Having said this, however, the secret is knowing how to loosen up if one is too tight and, at the risk of repeating myself again, how much safely to leave out.

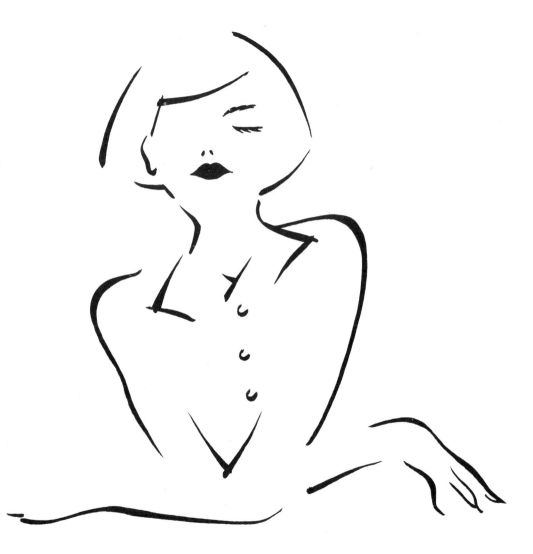

Brush pen sketch.
This drawing encapsulates
everything I feel about economy
of line. Suggestion is down to
the barest minimum, and imagination
fills in the gaps

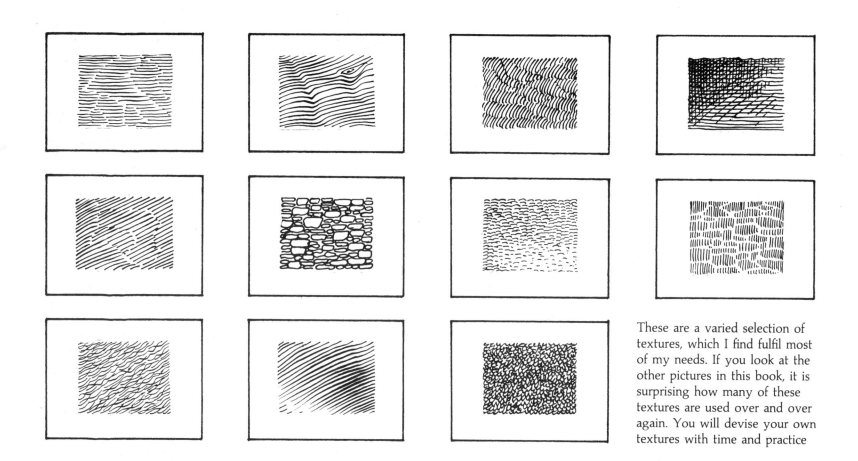

These are a varied selection of textures, which I find fulfil most of my needs. If you look at the other pictures in this book, it is surprising how many of these textures are used over and over again. You will devise your own textures with time and practice

As a consequence of this preamble, the rule of 'suggestion' raises itself. First of all we find ourselves staring at a completely blank, white piece of paper. What we do in a few simple lines will completely transform that virgin surface into a meaningful translation of our own subject.

Having briefly pencilled in the objects, landscape or other subject, and then inked-in the main outlines, we must indicate the materials and textures of the various components, such as the leaves on trees, and the slates, bricks or stones of buildings. The main objective at this stage is definitely *not* to draw every leaf on the tree, every blade of grass, or every brick and slate. This would not only be terribly boring, but would decidedly overdo, rather than enhance, the drawing.

It is far better to *suggest* the appropriate texturing: a few bricks in a wall, a mere indication of slates on a roof, and only the minimum amount of leaves on the tree or foliage. The imagination is far more capable of filling in the remaining spaces and, indeed, needs to exercise itself in this way, thereby giving the artist and the viewer far greater satisfaction. The 'golden rule', then, is simply to indicate in the white spaces in the drawing what these spaces represent or contain overall.

Now the big question arises as to where to put this 'suggestion' in order to gain the maximum effect? I have discovered, from experience, that concentrating the suggested textures around the *edges* of the object being drawn looks better than creating a lot of texture in the middle of the object.

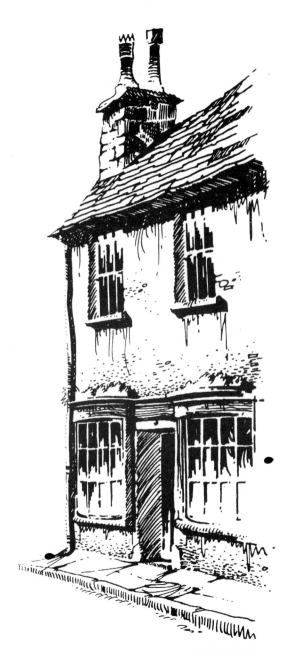

House detail showing how different textures are merely suggested

Cross-hatching and hatching provided most of the textures needed for this sketch

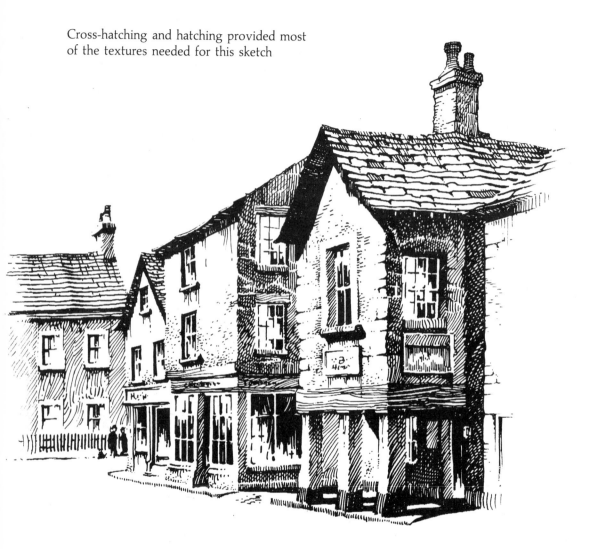

This helps to focus the eye more on the shape of the object rather than the centre of it, and the shape of the object has more interest than its middle — after all, the shape tells us what it is!

The chart on page 44 shows a few of the basic texturing techniques that I use in all my drawings, with variations, of course, where necessary. Practise just suggesting a texture, such as a few bricks or stones in the right places, a few slates on a roof area, or a scattering of stones on a beach. Look carefully at all my drawings and notice how these textures have been used in one form or another.

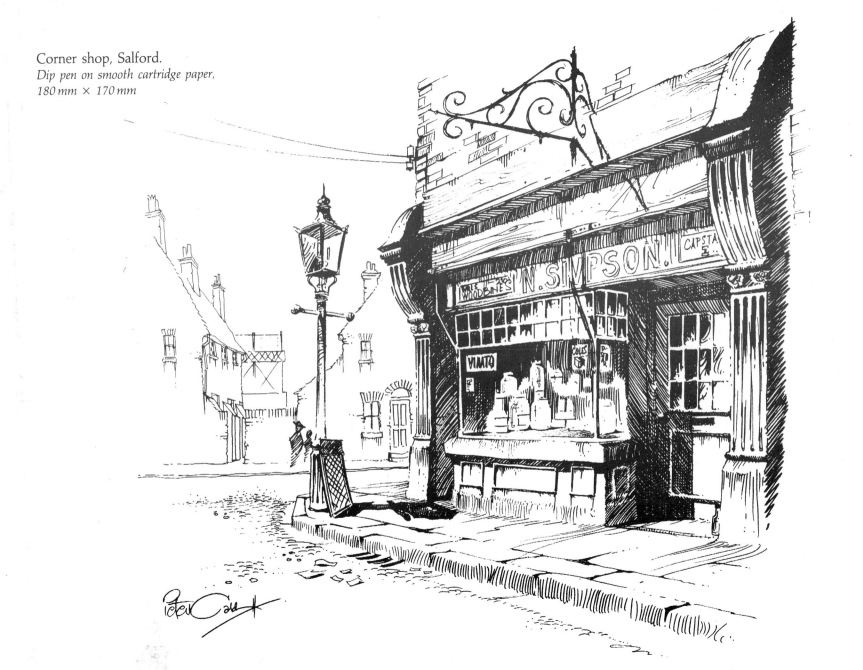

Corner shop, Salford.
Dip pen on smooth cartridge paper,
180 mm × 170 mm

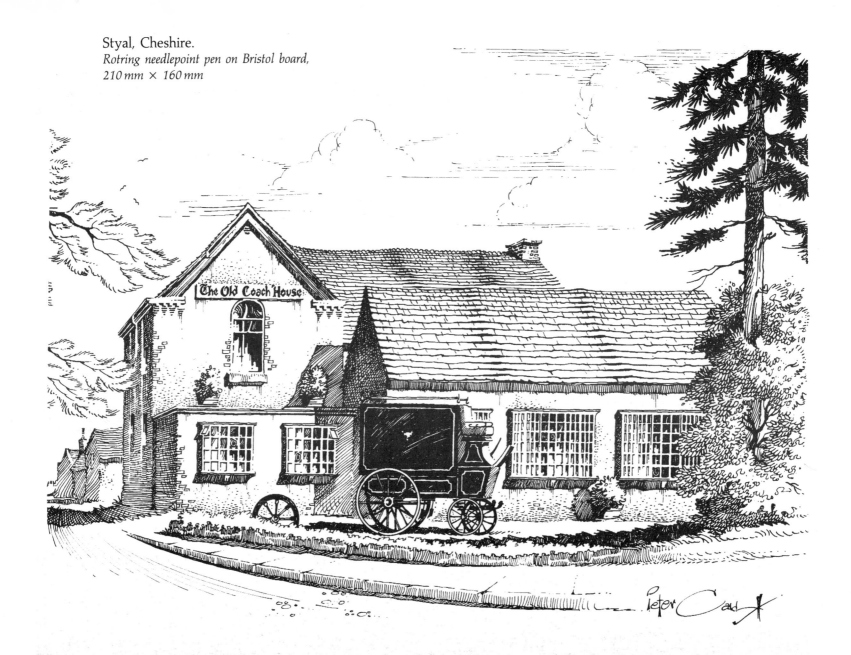

Styal, Cheshire.
*Rotring needlepoint pen on Bristol board,
210 mm × 160 mm*

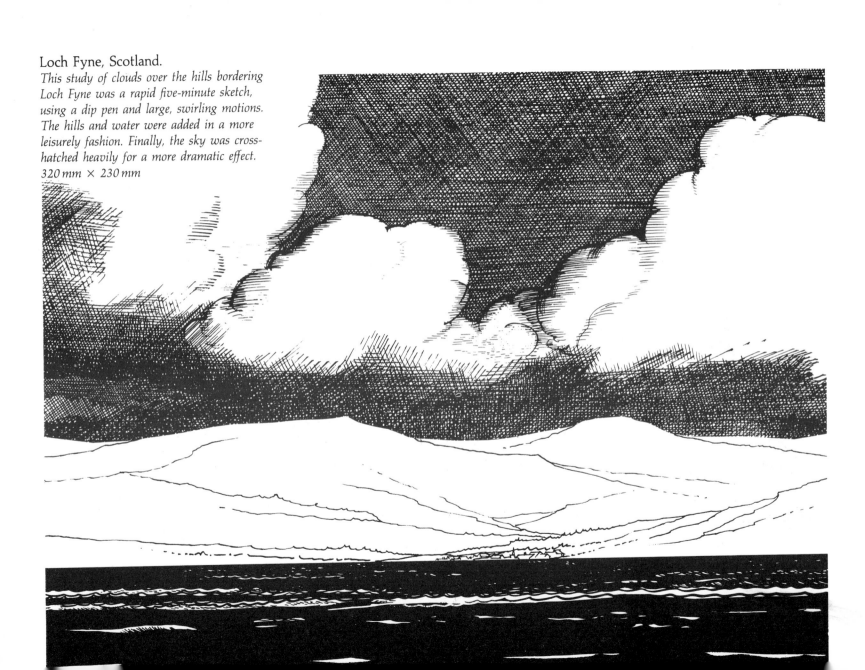

Loch Fyne, Scotland.

This study of clouds over the hills bordering Loch Fyne was a rapid five-minute sketch, using a dip pen and large, swirling motions. The hills and water were added in a more leisurely fashion. Finally, the sky was cross-hatched heavily for a more dramatic effect.
320 mm × 230 mm

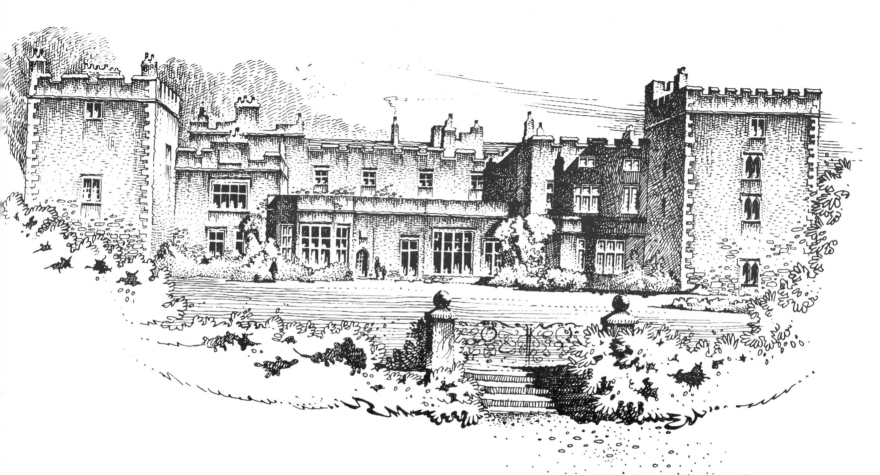

Muncaster Castle.
Dip pen on Bristol board,
240 mm × 120 mm

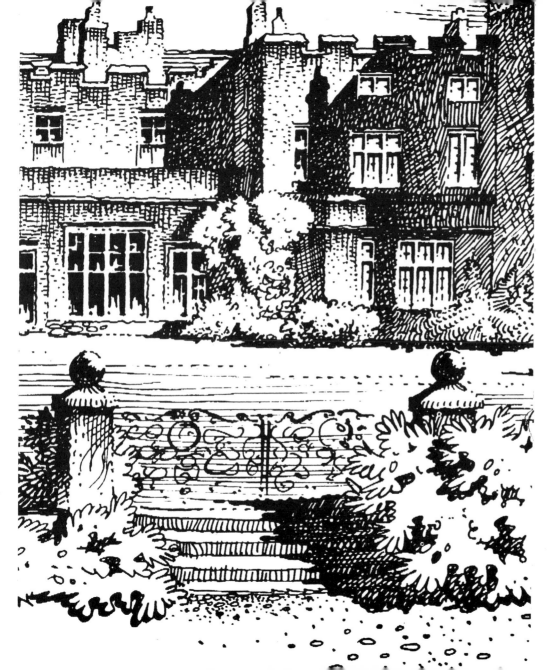

Enlarged detail of Muncaster Castle
(opposite), showing the simplified depiction
of stonework and foliage

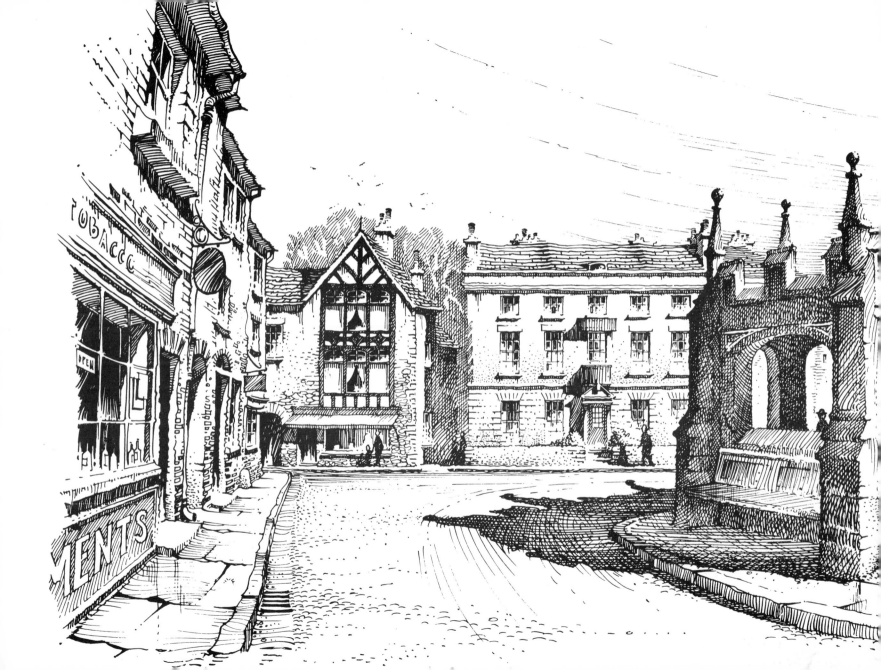

SUNLIGHT AND SHADOW

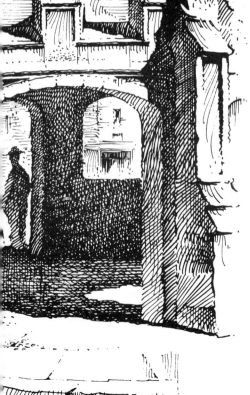

The previous chapter on suggestion brings us to the most wonderful of all natural phenomena – sunlight and shadows. Many artists tend to look at their chosen subject and become so full of anticipation and eagerness to put it down on paper that they completely overlook the lovely shadows which give form and atmosphere to the scene – shadows which create most of the appeal in the first place.

I cannot over-emphasize the beauty and importance of shadowing and cast shadows. There have been numerous occasions when I have gone out on a dull day, sketchbook at the ready, just to record the rather obvious lines and shapes in the landscape. Then suddenly, the sun has emerged and transformed the previously rather dead scene into a magical composition of light and dark areas. A very appropriate comparison can be made with a stage setting: unlit, it is quite daunting and lifeless, but when the lights are switched on the scene is bathed with life and atmosphere.

In this chapter I have carried out a number of drawings in which I have

Kirkby Lonsdale, Cumbria.
Dip pen on Bristol board,
180 mm × 120 mm

concentrated on the shadows only, relegating the objects *casting* the shadows to secondary importance. You must try to exploit light and shade to the fullest extent — even exaggerate them if you can — as they can transform our ordinary, workmanlike drawing into something special.

In general, by far the best way of drawing shadows and shading with pencils and pens is with *hatching* and *cross-hatching*. Stippling or dots can be used, of course, but I am concentrating on cross-hatching for our purposes. I shall touch on stippling, and show you one or two examples of this technique further on in the book (look at the palm tree on page 127, for instance). You will be able to exploit cross-hatching to the greatest advantage by remembering the following observations.

Bright sunlight has a tendency to glare on surfaces facing the sun. In your drawing, therefore, the side of a building

Simple sketch showing the use of solid black for the shadows inside the boats, and hatching for the shadows cast on the sand

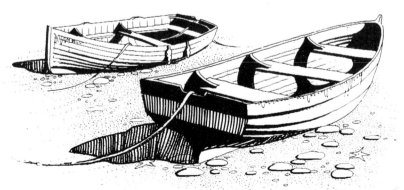

Muncaster Mill.
Technical pen on cartridge paper,
260 mm × 165 mm

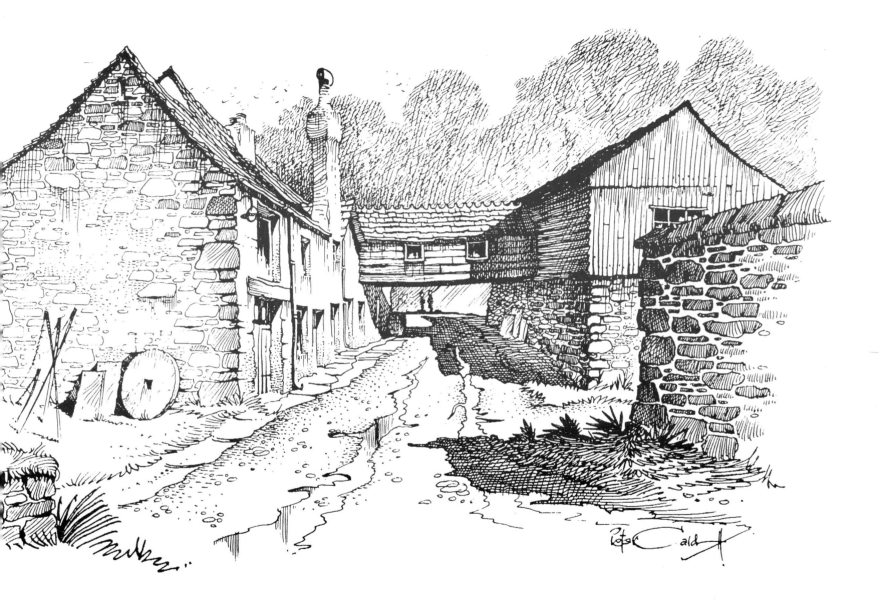

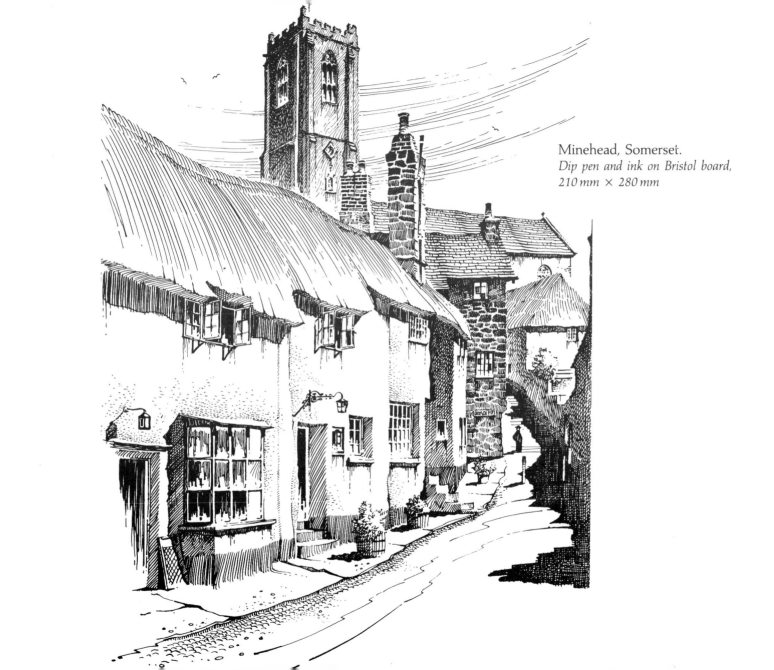

Minehead, Somerset.
Dip pen and ink on Bristol board,
210 mm × 280 mm

effect, this cast shadow should be darkest on the outside, gradually becoming lighter on the inside of the shadow. This effect is due to reflected light (sunlight bouncing off the ground or an adjacent building), which tends to lighten the *inside* of a shadow, giving a certain warmth to an otherwise dark, brooding·area. Do try to capture this atmosphere in your work with the method of cross-hatching I have suggested. It will give life and vitality to your drawings!

I would suggest that you re-read these notes slowly, referring all the time to my drawings, which show exactly what I am aiming for. Another good rule to keep in mind is that the darkest areas of any shadow occur near the outside edges, or where the shadow meets the bright, sunlit areas. As with any rules on shading or shadowing, it goes almost without saying that the less sun or light there is, the less intense the shadow will be.

This chapter on sunlight and shadow may seem, at first reading, rather to over-complicate what appears to be a simple issue of light and shade, or black and white. From personal experience, however, I think it is well worth the

Cross-hatching was used for the shadowed area of this subject

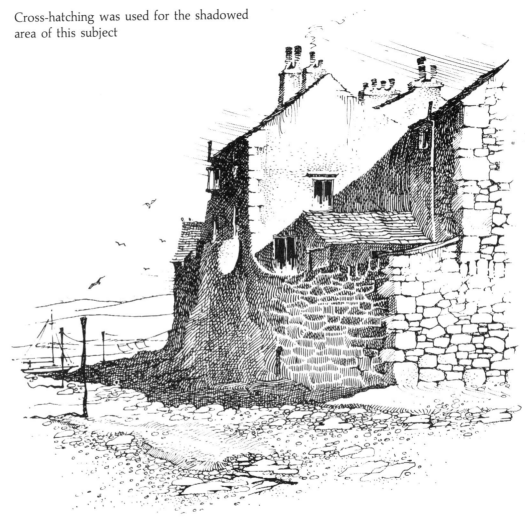

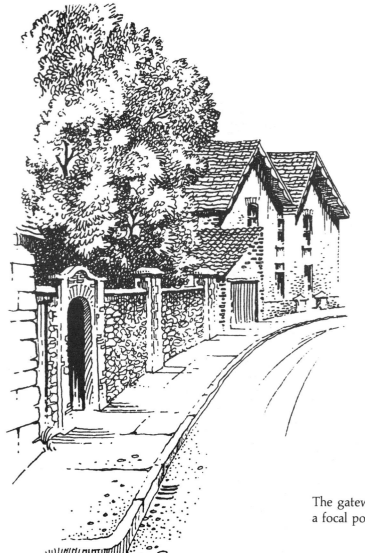

effort to practise and develop your shading technique using these methods. To recap:

- the lightest 'lights' occur next to the darkest 'darks'
- the 'cast' shadow is darker than the object in shadow, in bright sunlight conditions
- hint at, or only suggest, texturing detail on bright, sunlit areas – but let yourself go more with the texture in shaded areas, if they are sufficiently interesting
- the shadow cast by any building, or object, will follow the contours of the ground, or the shape of any other building or object, across which it falls

The gateway, filled in with solid black, is a focal point of this sketch

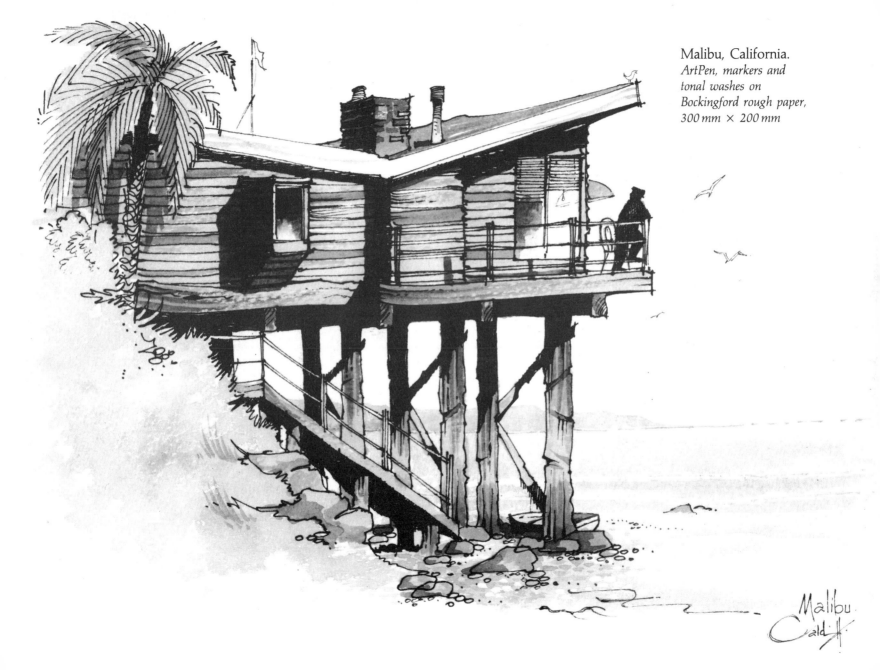

Malibu, California.
*ArtPen, markers and
tonal washes on
Bockingford rough paper,
300 mm × 200 mm*

Beaune, France.
Technical pen on cartridge paper,
215 mm × 215 mm

Tideswell, Derbyshire.
*Technical pen and tonal washes
on Bockingford rough paper,
330 mm × 300 mm*

Apart from the lines of the field and road, the whole technique comprises intertwining 'wiggly' lines, giving the scene a lovely unity and purpose

Sussex lane.
A different technique and adaptation, after the style of my 'mentor', the very talented Frank Patterson. Dip pen and ink on Bristol board, 165 mm × 180 mm

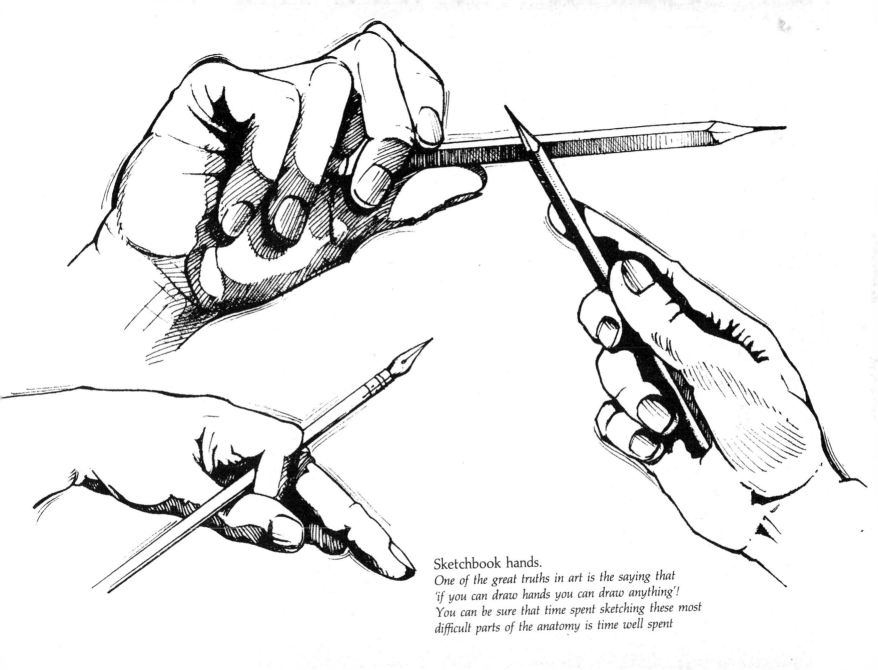

Sketchbook hands.

One of the great truths in art is the saying that
'if you can draw hands you can draw anything'!
You can be sure that time spent sketching these most
difficult parts of the anatomy is time well spent

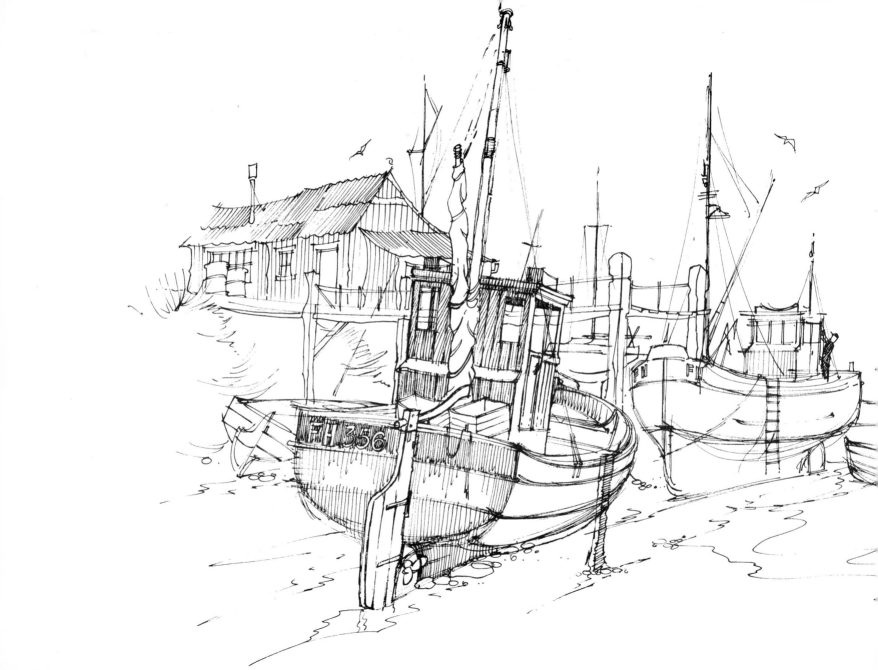

COMPOSITION AND LAYOUT

All pictures great and small, including drawings, sketches, and even doodles, need to have composition or balance. Put another way, they all need to embody some sort of shape or sense of design to please the eye.

The following basic compositions can usually be picked out in most good pictures in any gallery. It would be an interesting exercise, the next time you have the opportunity to view a collection of professional works, to examine the pictures, not particularly for their subject matter but, rather, to appreciate the artist's sense of design. In so doing, try looking at the work through half-closed eyes to blur the

Falmouth, Devon.
Technical-pen 'atmosphere' sketch on cartridge-paper layout pad, 360 mm × 230 mm

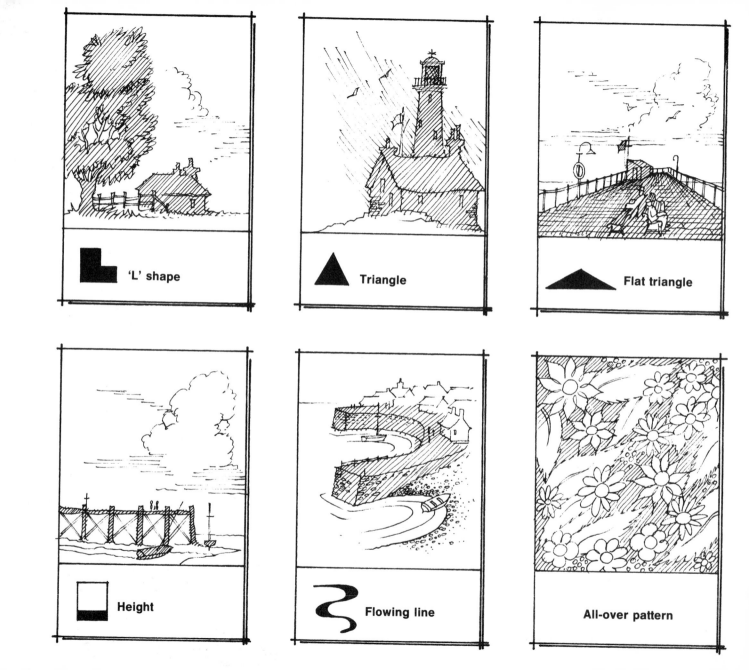

'L' shape

Triangle

Flat triangle

Height

Flowing line

All-over pattern

RIGHT:
A good composition makes the simplest subject interesting

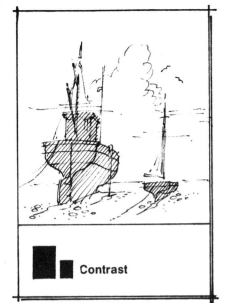

Contrast

detail and allow you to see just the shapes and main elements.

Only with constant practice and sharpened observation does the eye start to analyse, quite naturally, those subjects which really lend themselves to a good composition. Make up your mind what it is about the subject which appeals to you, and then enhance or exaggerate that appeal, even to the exclusion of other attractions. Don't be side-tracked when doing this: the other attractions can await their turn as possible subjects

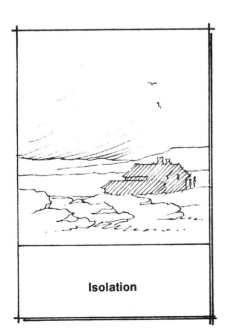

Isolation

LEFT:
Composition chart. Generally speaking, whatever pleases us visually conforms to some sort of arrangement. In nature it may have happened in a random way. Sometimes we are not aware of why certain subjects catch our eye, while others pass unnoticed. The chart gives a helpful clue to just a few recurring compositions

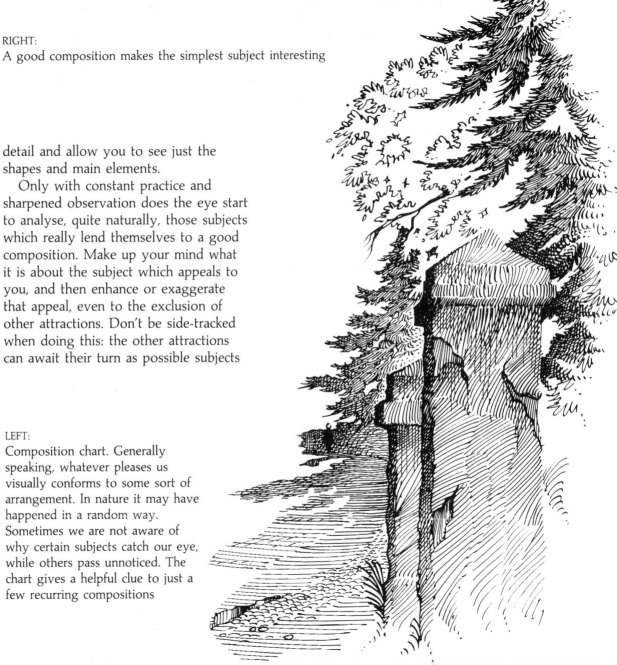

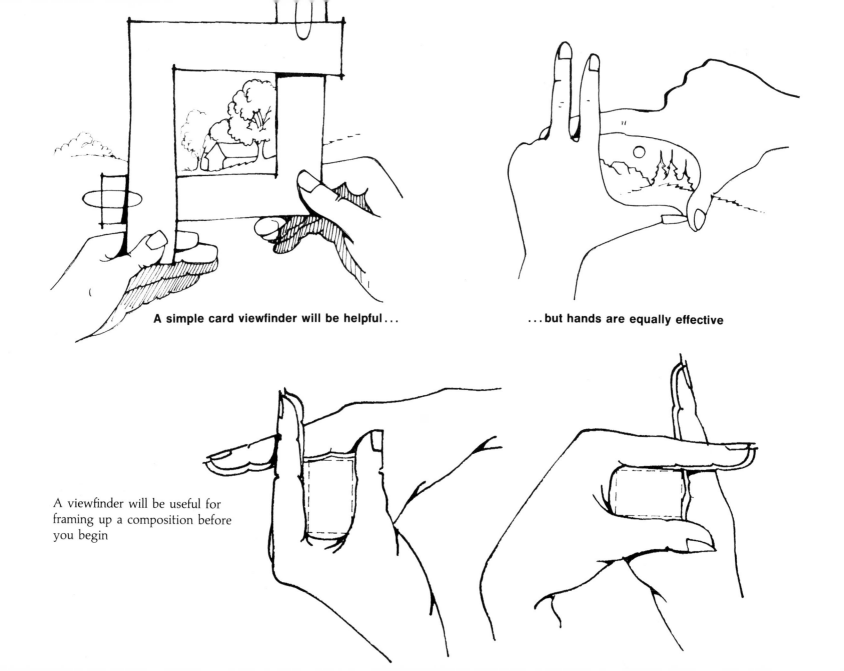

A simple card viewfinder will be helpful...

...but hands are equally effective

A viewfinder will be useful for
framing up a composition before
you begin

for another time. Think about what you are going to do, how you are going to tackle the subject and with what. You should almost be sketching the subject in your mind's eye, even to the extent of imagining the finished picture and the effect you are trying to achieve.

Choose an original viewpoint if possible or, at least, an angle on the subject which shows it off to its best advantage. For example, if the appeal of an ancient barn lies in its being hemmed in by tall woodland trees, then don't draw the scene so close up that you have to exclude most of the trees. You might find that looking through an old cartwheel, with long grass in the foreground, adds to the secluded atmosphere. Likewise, you might be drawing an isolated lighthouse on a headland, in which case it would certainly add to the loneliness of the scene to show the vast, even threatening, sky dominating the lighthouse.

Some artists need a simple 'viewfinder' to frame up a possible composition. In time, of course, good judgement will be sufficient to tell you which subjects have a nice balance.

Meanwhile, a viewfinder will help you to spot a promising arrangement. Two pieces of 'L'-shaped card held together with a couple of paper clips will form a square or rectangular aperture; this simple device will enable you to isolate otherwise distracting arrays of features in a landscape. All is not lost if you do not have a card viewfinder available – simply use your hands in the manner shown opposite!

This pigeon was quickly depicted using hatching and cross-hatching. This type of drawing forms very useful sketchbook reference

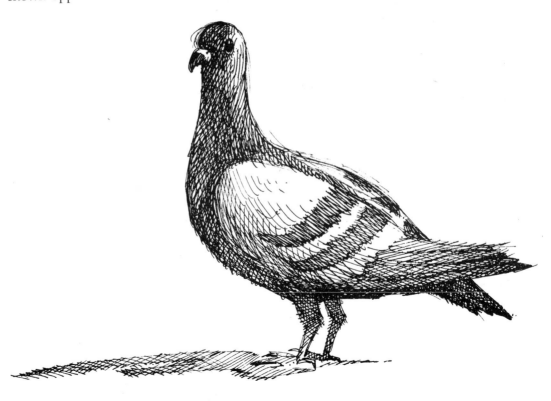

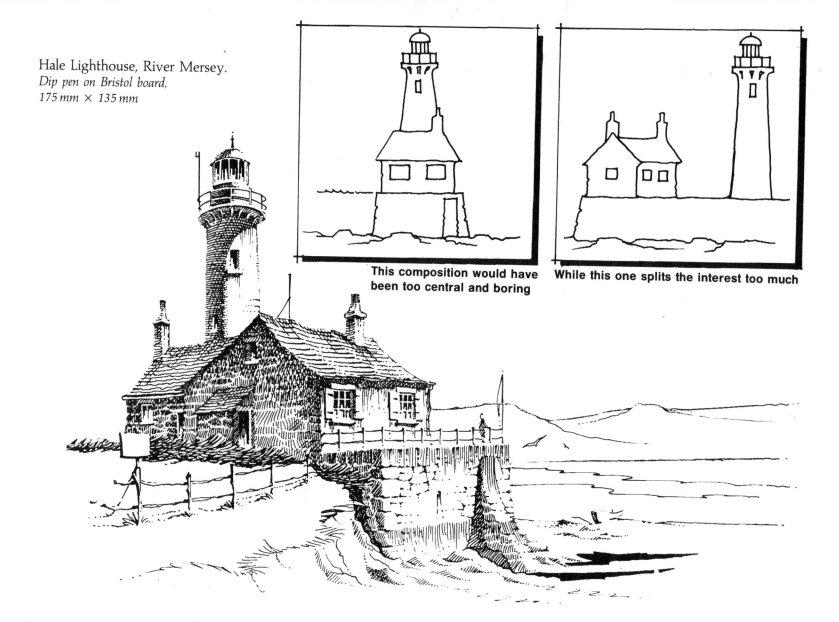

Hale Lighthouse, River Mersey.
Dip pen on Bristol board,
175 mm × 135 mm

This composition would have been too central and boring

While this one splits the interest too much

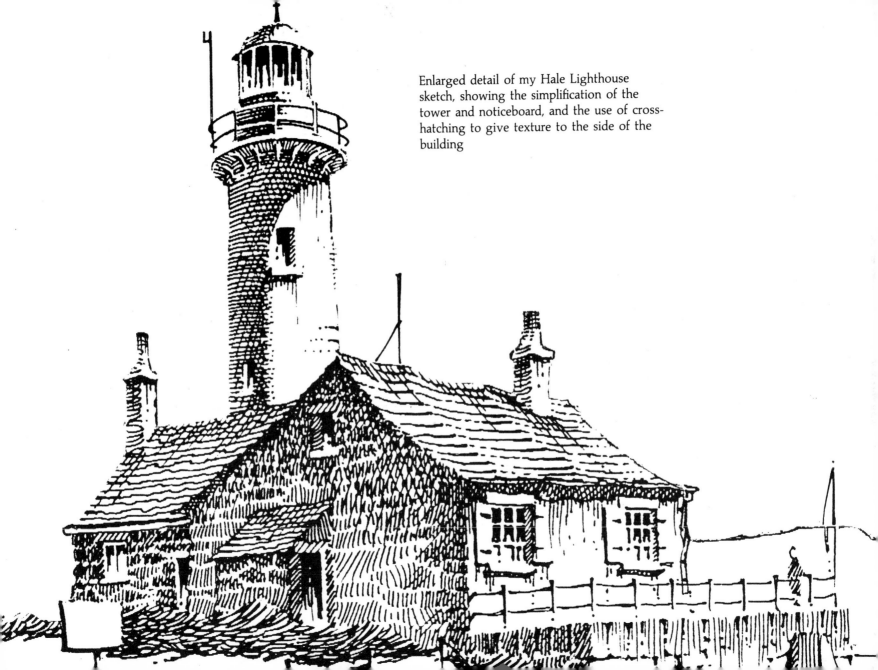

Enlarged detail of my Hale Lighthouse sketch, showing the simplification of the tower and noticeboard, and the use of cross-hatching to give texture to the side of the building

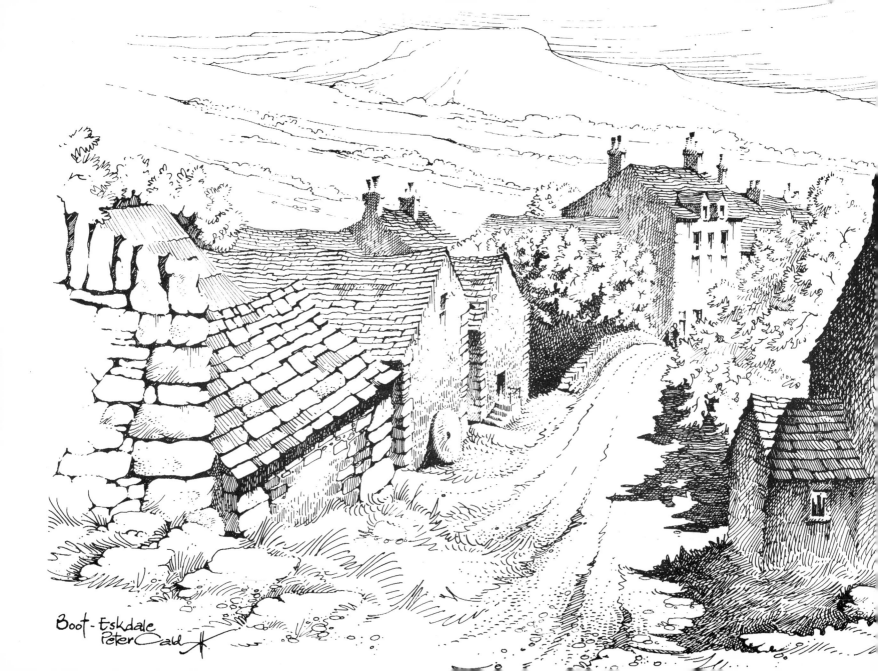

Boot - Eskdale
Peter Cald

Chapter 9

PERSPECTIVE

To most beginners (and, I suspect, a few experienced artists) the very mention of the word 'perspective' brings out a reaction of horror. Of course, I would be the first to admit that, presented in its true scientific/geometric 'colours', it does seem a rather awe-inspiring challenge.

An appreciation of perspective and all that it implies is, however, really essential if your drawings are to have any ring of truth. Bad perspective can ruin your picture no matter how well you pay attention to other details. Nor can you gloss over it with additional drawing in the vain hope that the viewer won't notice. In fact, I would go so far as to suggest that, as long as the perspective looks right, your technique can take second place. After all,

Boot village, Eskdale.
Dip-pen drawing on Bristol board,
280 mm × 190 mm
Note: I was standing on high ground looking
down on to the village. Just to make life
more difficult, the road also sloped away downhill

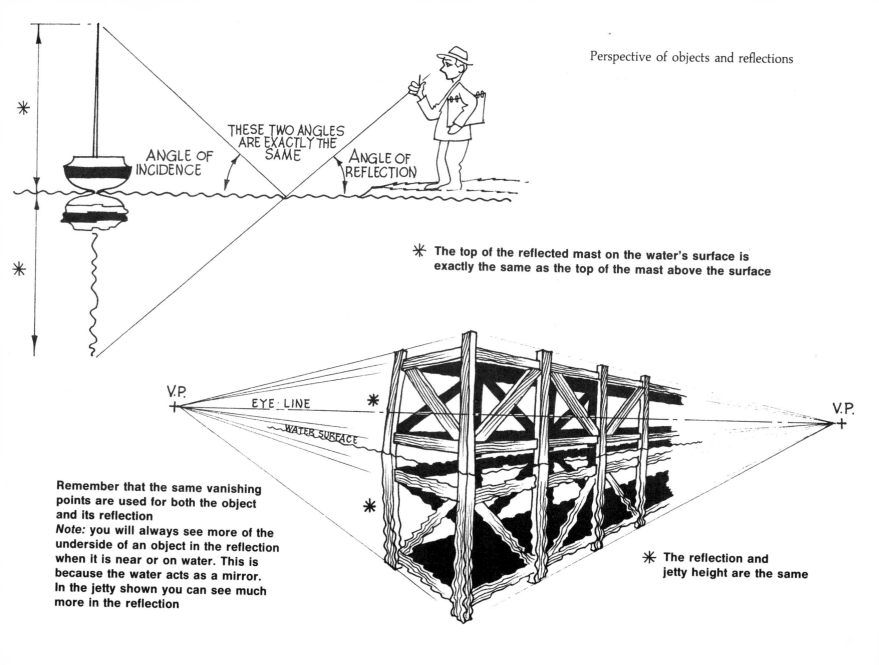

Perspective of objects and reflections

ANGLE OF INCIDENCE

THESE TWO ANGLES ARE EXACTLY THE SAME

ANGLE OF REFLECTION

❋ **The top of the reflected mast on the water's surface is exactly the same as the top of the mast above the surface**

V.P.

EYE LINE

WATER SURFACE

V.P.

Remember that the same vanishing points are used for both the object and its reflection
Note: **you will always see more of the underside of an object in the reflection when it is near or on water. This is because the water acts as a mirror. In the jetty shown you can see much more in the reflection**

❋ **The reflection and jetty height are the same**

technique and style are aspects which improve of their own accord with time and practice.

Perspective is a bugbear to many aspiring artists, and the more they try to get to grips with complicated rules and formulae, the more nightmarish the whole business becomes. Some artists have a natural feeling and flair for good perspective, and rely to a great extent on their judgement as to what looks right; they can see where they may have strayed, and can correct it. From my own working experience, I thoroughly enjoy drawing perspective – the more complicated the subject, the better! However, I do appreciate the problems that many people face. On my painting and drawing courses I spend some time explaining and demonstrating simplified guidelines to achieving a good result.

You will see from the simple perspective diagrams I have drawn in this chapter that three important factors always need to be remembered.

1 The most obvious point, which hardly needs mentioning, is that everything diminishes in size the further away it is from the viewer. You might get away with bad perspective for objects in the distance, but you will not do so with features near to you, where the eye is more focused and therefore more critical.

2 The second factor to be considered is your *eye-line*. Before you even start to draw, and assuming that the subject is a village street, a faint horizontal line should be drawn approximately half-way between the

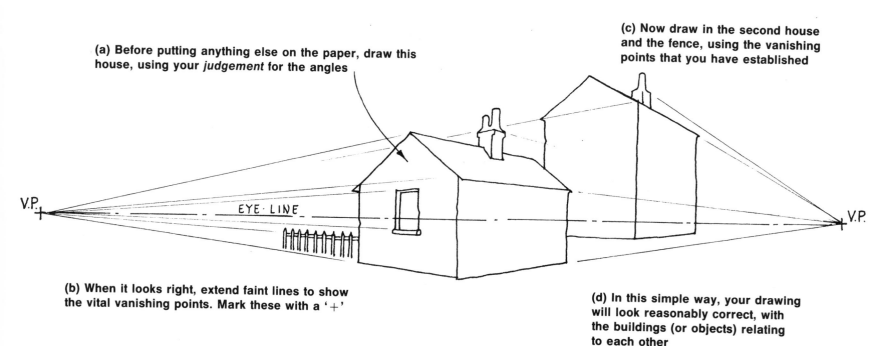

(a) Before putting anything else on the paper, draw this house, using your *judgement* for the angles

(c) Now draw in the second house and the fence, using the vanishing points that you have established

V.P.

EYE·LINE

V.P.

(b) When it looks right, extend faint lines to show the vital vanishing points. Mark these with a '+'

(d) In this simple way, your drawing will look reasonably correct, with the buildings (or objects) relating to each other

top and bottom of your blank page, and from the left edge across to the right edge; this indicates your eye-line. Bearing in mind that you may be seated or standing up, whatever is in front of you and in line with your eye *must* be drawn horizontally along this eye-line.

For example, if the village street going into the distance is level, and you are sitting on a stool to draw, then the chances are that your eyes are just about level with all the lower window sills. In this case, all the lower window sills will be drawn straight on to the faint eye-line – not forgetting, of course, that they will be getting smaller as they recede along the street. Likewise, if you are standing, your eyes will probably appear to be level with the tops of the doors. The same rule applies, as this will now be your eye-line.

3 This brings us very nicely to the third factor: the *vanishing point* or *points*. A vanishing point is, very simply, the approximate place in the distance at which lines converge. This is marked for our purposes with a pencil dot on the eye-line. All the guidelines *above* the eye-line will slope downwards, and all the guidelines *below* the eye-line will slope upwards. These guidelines will appear to merge at a certain point on the eye-line. This is a vanishing point (V.P.) for one side of the village street, and everything in the drawing – window sills, line of roof, chimney pots, pavement line and road – *must* be drawn sloping toward this vanishing point. Equally, the same procedure will apply to the other side of the street, which has its own vanishing point.

If you are worried about where vanishing points will be, you can

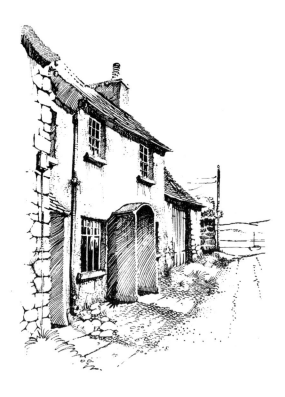

This simple perspective drawing shows quite clearly how the angles converge into the distance to form the vanishing point

always check this by holding your pencil in front of your eyes and lining it up with, for example, the edge of the roof. Take note of the angle that the pencil assumes, and try to transfer that angle to your paper. Imagine where the angle line will cross your eye-line, and that is your vanishing point. Now, as a check, do the same thing with the pavement kerb line and transfer that angle to your paper. It should touch the eye-line at the same point as the roof guideline, confirming where the vanishing point lies. Don't forget that everything else you draw should slope in towards this vanishing point.

All the subjects that you will tackle – be they a table, a chair, or a church tower – will conform to these basic guidelines. As a final note, don't throw your hands up in despair if your vanishing point disappears off the edge of your sheet of paper, as will happen from time to time. The only answer is to make a mental note and to try to imagine how far away from the edge of the paper it appears to be. If your confidence is liable to be shattered you can always tape an extra piece of paper to the edge of your drawing sheet.

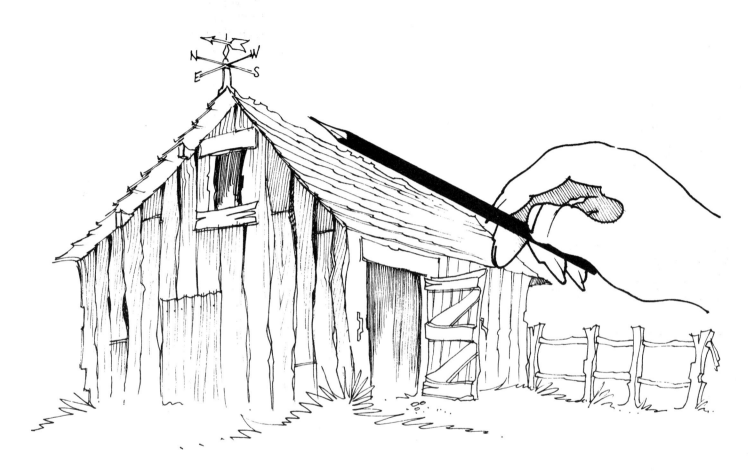

Hold your pencil in front of your
eyes and line it up with, for example,
the top of a roof, making a mental note
of the angle. This is a rough guide
used by many artists

(1) 290mm X 230mm
OR
240mm X 190mm
OPENING

Use a picture mount as a perspective frame. Serrate the edge all round. The sizes I have shown will suit the needs of most artists

(2)

Half-a-dozen large, thin elastic bands are usually sufficient to cover the most important angles to be drawn

Using a simple frame such as the one shown here is an easy way of dealing with difficult angles

If all else fails, and you still find my explanation a little hard to digest, I have devised a perspective frame, shown here, which is simplicity itself. If it is any consolation, the more you tackle perspective, the easier it gets. With repetition and practice any inhibitions you might have will fade until, ultimately, you will thoroughly enjoy the challenge.

Holding the frame to include the view of your choice, place the elastic bands to coincide with the main angles of the subject

(5)

Holding the frame in front of you like a viewfinder, compose the choice and size of the picture you wish to draw

③

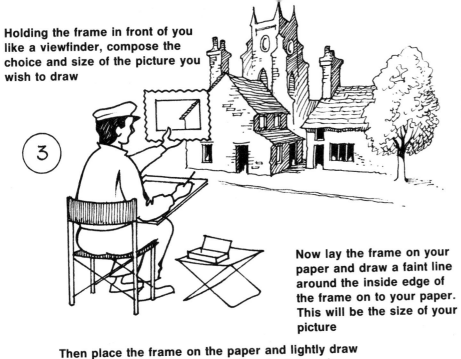

Now lay the frame on your paper and draw a faint line around the inside edge of the frame on to your paper. This will be the size of your picture

④

Then place the frame on the paper and lightly draw all the main lines indicated by the elastic bands

⑥

You can now finish the picture with confidence

⑦

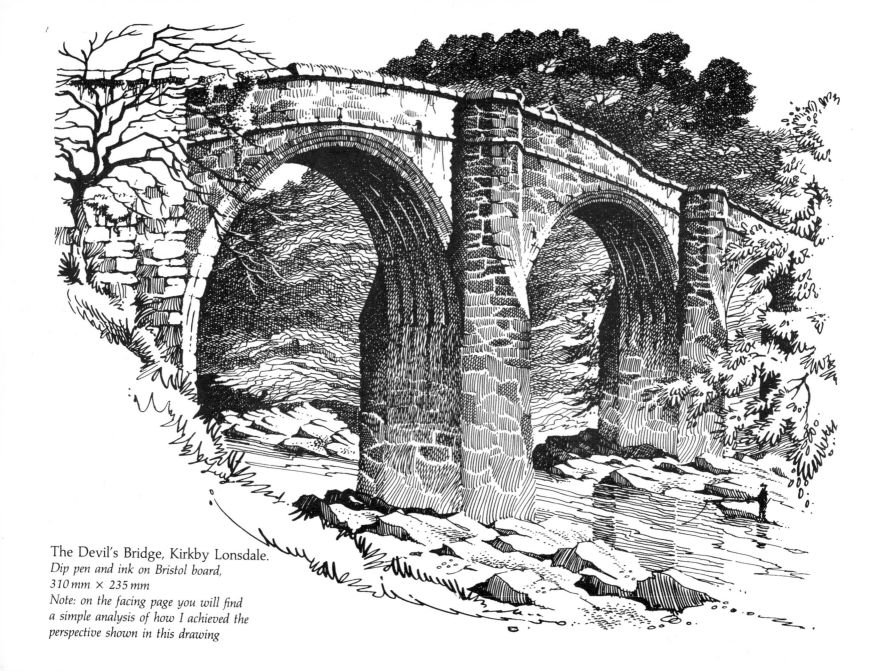

The Devil's Bridge, Kirkby Lonsdale.
Dip pen and ink on Bristol board,
310 mm × 235 mm
Note: on the facing page you will find
a simple analysis of how I achieved the
perspective shown in this drawing

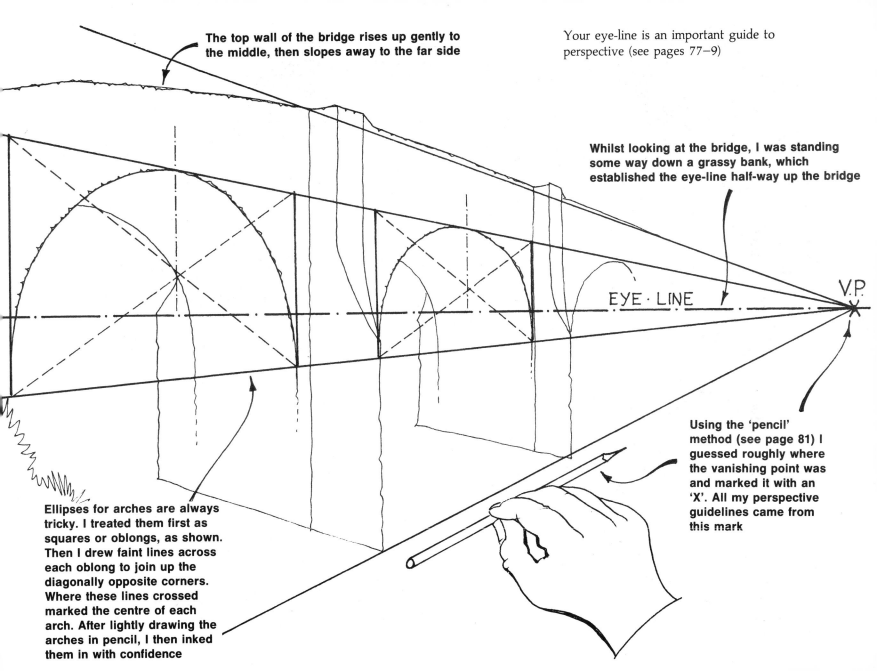

The top wall of the bridge rises up gently to the middle, then slopes away to the far side

Your eye-line is an important guide to perspective (see pages 77–9)

Whilst looking at the bridge, I was standing some way down a grassy bank, which established the eye-line half-way up the bridge

EYE · LINE

V.P.

Using the 'pencil' method (see page 81) I guessed roughly where the vanishing point was and marked it with an 'X'. All my perspective guidelines came from this mark

Ellipses for arches are always tricky. I treated them first as squares or oblongs, as shown. Then I drew faint lines across each oblong to join up the diagonally opposite corners. Where these lines crossed marked the centre of each arch. After lightly drawing the arches in pencil, I then inked them in with confidence

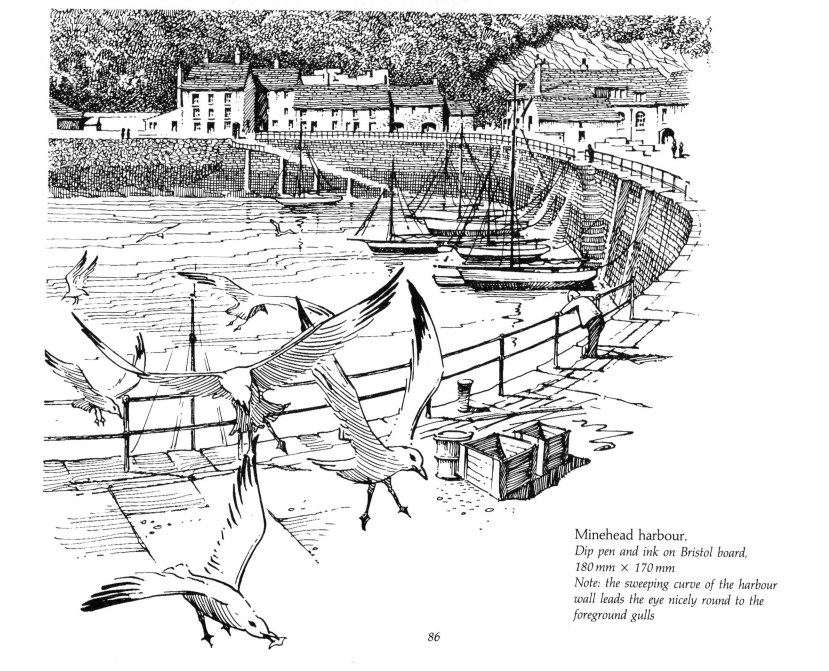

Minehead harbour.
Dip pen and ink on Bristol board,
180 mm × 170 mm
Note: the sweeping curve of the harbour
wall leads the eye nicely round to the
foreground gulls

Courtyard gate, Gibraltar.

Technical pen and tonal washes
on Bockingford rough paper,
235 mm × 260 mm
Note: perspective does not always
rely on dramatic sloping surfaces
receding into the distance.
It can also be achieved with a
strongly drawn flat foreground,
behind which a softer
background can be introduced

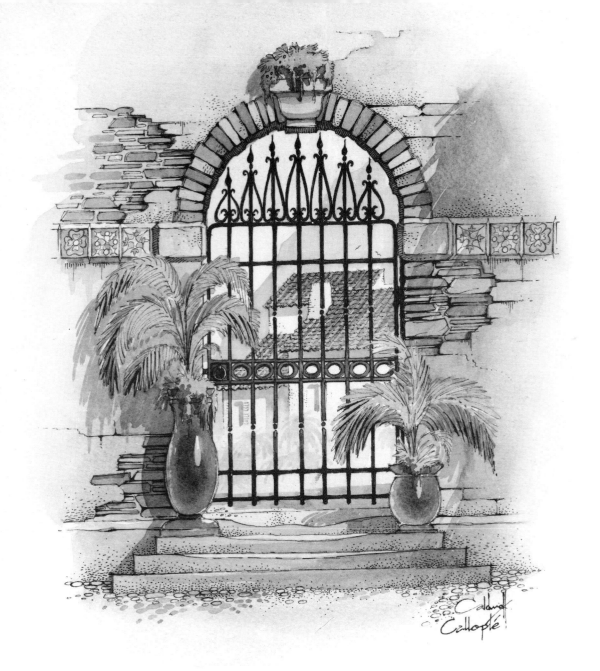

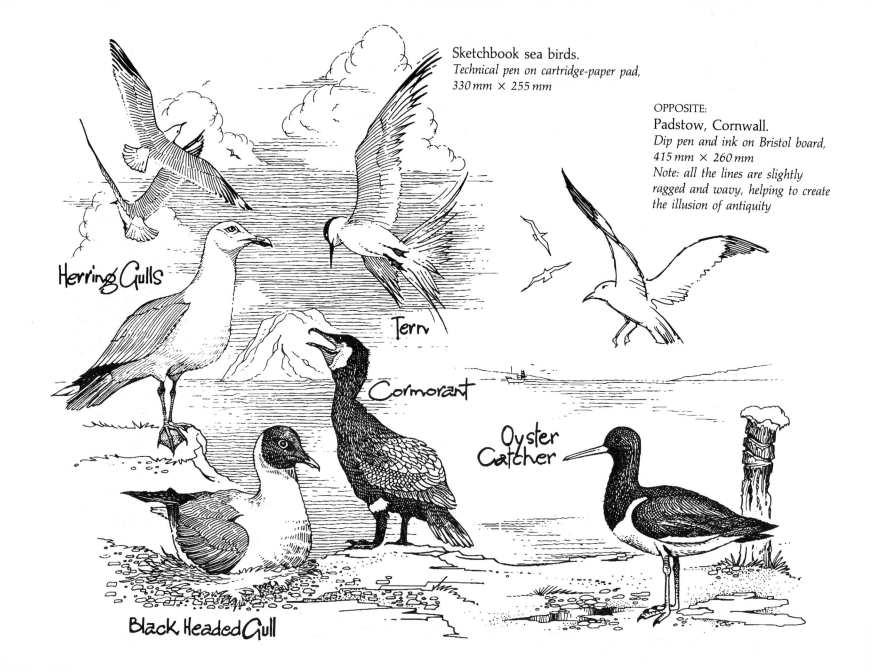

Sketchbook sea birds.
Technical pen on cartridge-paper pad,
330 mm × 255 mm

OPPOSITE:
Padstow, Cornwall.
Dip pen and ink on Bristol board,
415 mm × 260 mm
Note: all the lines are slightly
ragged and wavy, helping to create
the illusion of antiquity

Herring Gulls

Tern

Cormorant

Oyster Catcher

Black Headed Gull

GETTING LIFE AND CHARACTER
INTO A DRAWING

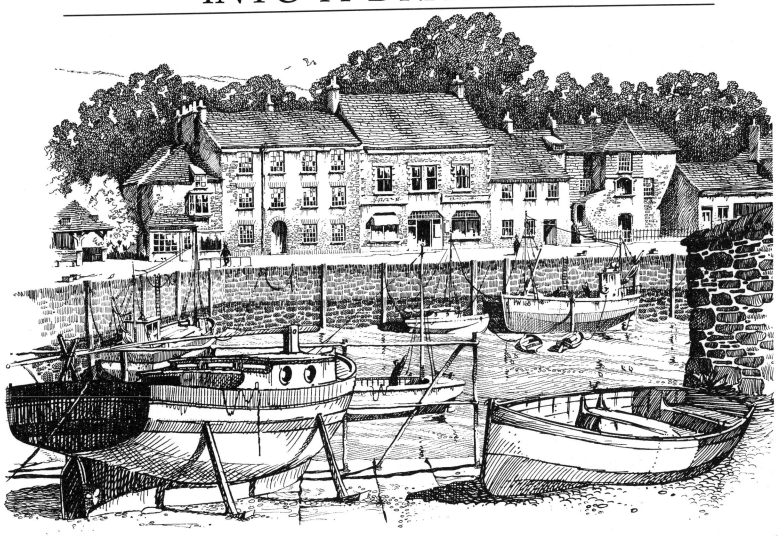

Clinical line drawn with ruler

Pressure thick-and-thin line with dip pen

Ragged, nervous line imparting liveliness

Overlaid lines implying movement

Brush and ink: strong black and dry-brush marks

A sharpened matchstick dipped into ink and used as a nib adds character

A sharpened cane shaped like a broad quill

The end of a pencil dipped into ink is perfect for berries and grapes

Almost anything dipped into ink is capable of making an interesting mark. It is then a question of adapting these marks to suit the subject. See the razor-blade study overleaf

A razor blade or old plastic credit card dipped into a saucer makes lovely broken lines

90

Many beginners believe that artistic progress lies along the straight-and-narrow path, toward the ultimate goals of perfection of line and an almost photographic interpretation of a subject. If we were to follow this rule rigidly we would simply end up with an almost clinical facsimile of the subject, which could have been recorded faster and better with a camera! In fact, all that we would end up with would be something more to the credit of a skilled draughtsman than an artist. While one can only admire the dedication needed to pursue this ideal, surely the main purpose of art in any shape or form is to allow an individual the freedom to express his or her impressions or feelings for an object, place, or living thing, rather than slavishly copying every factual line, curve or detail in the most exact way.

Although good draughtsmanship is something that we can all appreciate, it must not be confused with an artistic interpretation of a subject. As the saying goes, 'nature abhors a straight line', and I certainly try to reflect this maxim in everything I draw. The slightly wavy line, or one with a ragged look, always conveys a liveliness when compared with the line drawn using a ruler. In other words, it gives the line 'character'.

Extending this thought process into the rest of our work, we can also use drawing tools other than pens to give us more interesting lines and textures, thereby giving character to our drawings. I am in no way trying to decry the use of pens because, in fact, I use pens of one sort or another for about 80 per cent of my work, but it is the way I manipulate the pen in my hand which makes the line or mark I am trying to achieve. In other words, I use a pen to make a *purposeful* mark, whereas with a cruder instrument – such as a sharpened matchstick or a piece of

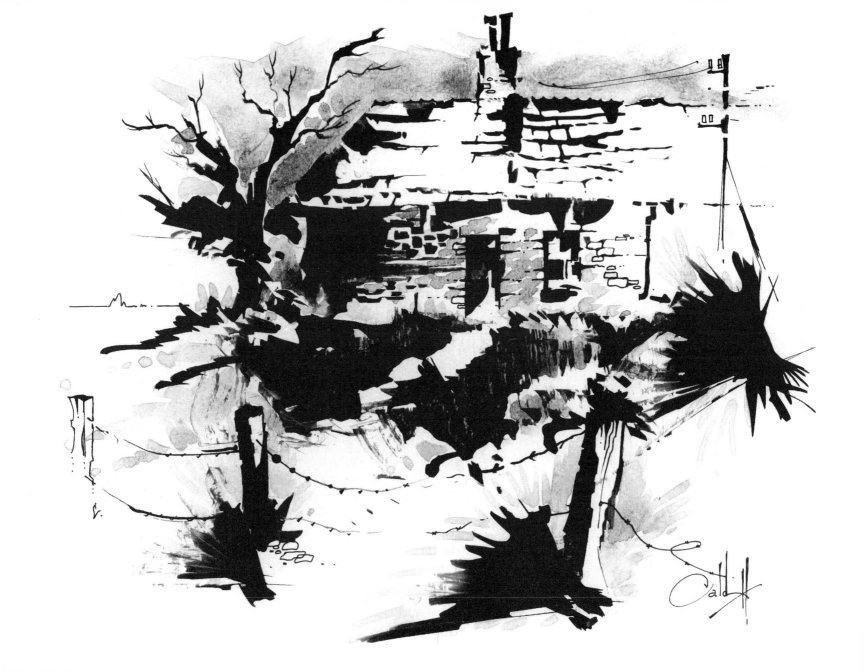

garden cane – little vagaries and distortions creep in.

These unintentional variations are also referred to as 'happenings' or 'happy accidents', and they can give your drawings a more spontaneous, lively appearance. You will see exactly what I mean from the examples carried out with assorted 'bits and pieces', shown on page 90. Even a razor blade has its uses, although an old plastic credit card is just as effective. After dipping its edge into a saucer of ink, lines can be 'planted' on to the paper and the ink spread around, using the card like a scraper. I have shown opposite a little sketch of a barn worked entirely with a razor blade. When you do play around and doodle with these alternative 'markers', the secret of success is to remember what these happenings, or happy accidents, achieve on the paper, and then to try for them in a more positive way in your next picture.

OPPOSITE:
This little picture was a fun exercise. It was carried out entirely with a razor blade, using the sharp edge gently, but spreading the ink vigorously

WEATHERING AND AGEING
These are techniques that I particularly enjoy when I am drawing or painting. I usually leave the actual business of weathering or ageing to the very end. Having more or less completed the picture, I then start the 'magical' process of adding all those little touches that make the subject look as if it has been around for a few years and been well-used, or has faced the full brunt of the wind and rain. These ageing touches can completely transform an otherwise rather clinical, clean, boring picture!

Weathering takes its toll on all things exposed to the elements, and is the general effect of the age and rain marks which appear on all exterior walls and surfaces. All protrusions and fittings – such as sills, signs, carvings and overhanging roof eaves – cause the weathering drip stains that result from wind and rain beating against the building. Accumulated water and dirt, or

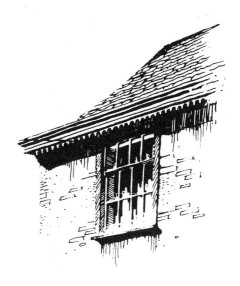

This simple window detail shows the effects of weathering beneath the sill and eaves

rust, drip down the walls beneath these protrusions, and, over a long period of time, discoloration occurs. Rainwater collects on window sills, and the walls immediately beneath become particularly vulnerable to drip stains. The next time you are visiting an old fishing harbour, look at the weathering on the stone, and particularly at the tidemark. On fishing trawlers, notice the rust marks dripping down the hulls from the anchor chains, scuppers and cleats.

Take note of the effects of weathering on boats and other items exposed to the elements

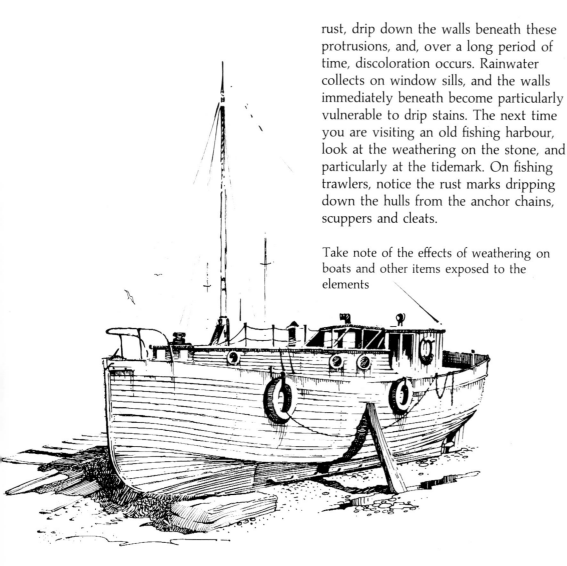

REFLECTIONS IN WINDOWS

Windows, like mirrors, reflect whatever is facing them, but, unlike mirrors, window glass is often slightly distorted. In addition, a pane of glass is never quite in line with the pane next to it, so that what we end up with in the reflection is a rather messy, twisted version of the view.

There is no need to go to any great lengths to reproduce the shape of the reflection. You will enliven the window if you draw dark, odd, unfinished 'splodges' on the area of glass – as in the small sketch on the previous page. Notice how my splodges of reflective patterns start off as solid, dark panes at the top of the window, but gradually break up, leaving the bottom of the window clear and white.

What one has to remember is that the dark interior of a room becomes rather mixed up with the dark reflections opposite, resulting in vague, abstract areas and patterns which are disciplined by the geometrical square or oblong window bars. Of course, windows in the top part of a building will reflect mostly sky, so any dark panes of glass will usually be at the bottom of the window. Windows at street level will be

Rotring needlepoint pen

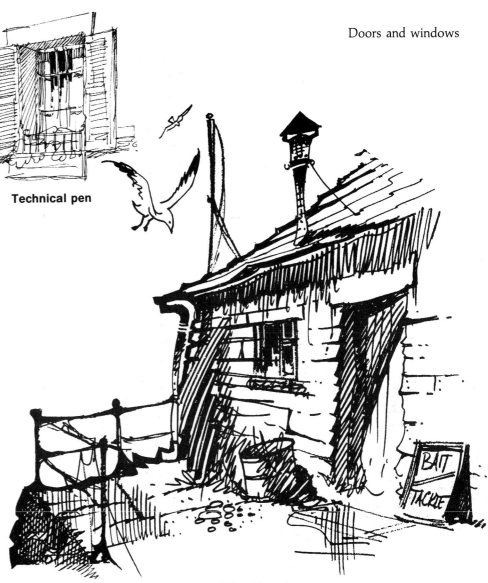

Technical pen

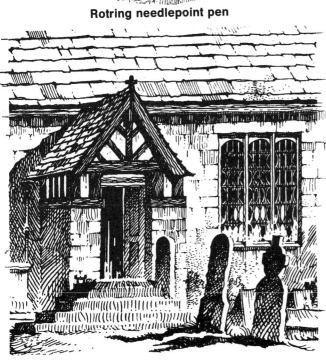

Dip pen

Fibre-tipped pen

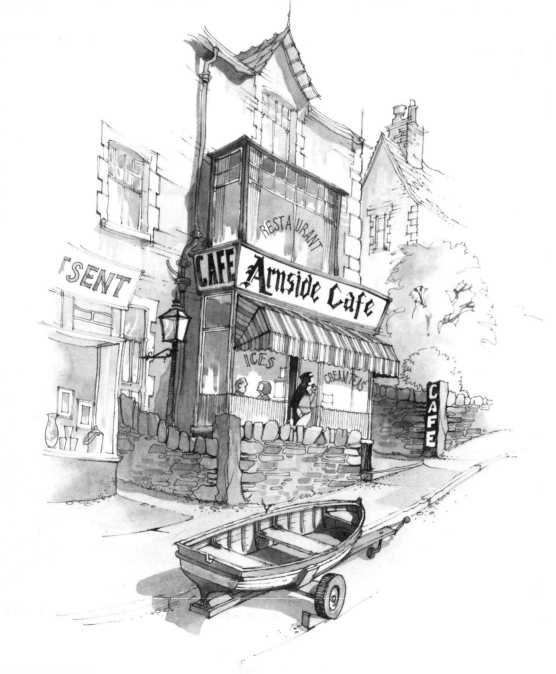

reflecting a lot more of whatever is opposite. To keep the window looking as interesting as possible, do emphasize, with your darkest areas, either the top or bottom of the window, gradually fading off with the reflections.

WATER AND SKY
Every time I talk or write about some aspect of pen-and-ink drawing, I always come back to the most important point to remember – simplicity! Try to do everything in the simplest, clearest way. There couldn't be two better examples of the advantages of subtle suggestion than water and sky.

Unlike buildings and all solid objects, which are more or less permanent and static, water and sky, by their very nature, are always on the move. We can only hope to capture fleeting glimpses of their movement, and it would be quite wrong – and even laborious – to attempt to 'freeze' large, detailed areas. Imagination can really be allowed a full

Arnside café.
Dip pen and ink on cartridge paper,
240 mm × 300 mm
Note: this drawing was done 'on the
spot' without any preliminary pencil
work. The washes were brushed on
very wet to achieve soft, merging colours

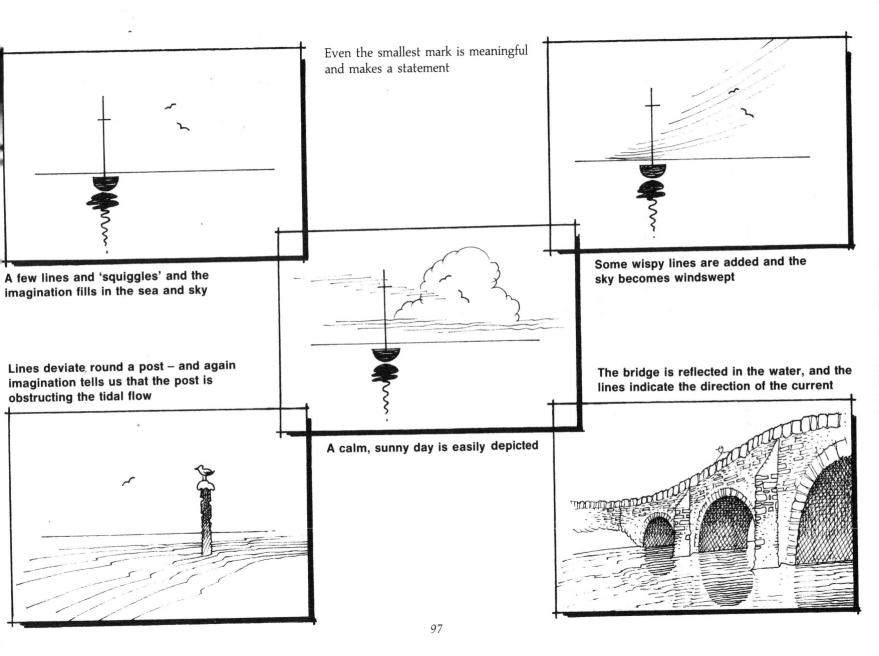

Even the smallest mark is meaningful and makes a statement

A few lines and 'squiggles' and the imagination fills in the sea and sky

Some wispy lines are added and the sky becomes windswept

Lines deviate round a post – and again imagination tells us that the post is obstructing the tidal flow

The bridge is reflected in the water, and the lines indicate the direction of the current

A calm, sunny day is easily depicted

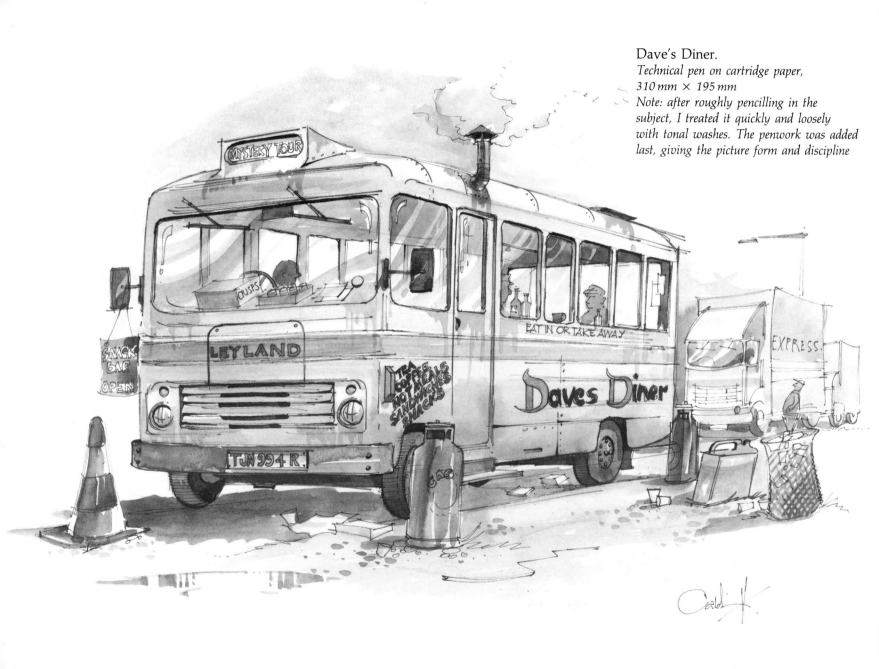

Dave's Diner.
Technical pen on cartridge paper,
310 mm × 195 mm
Note: after roughly pencilling in the
subject, I treated it quickly and loosely
with tonal washes. The penwork was added
last, giving the picture form and discipline

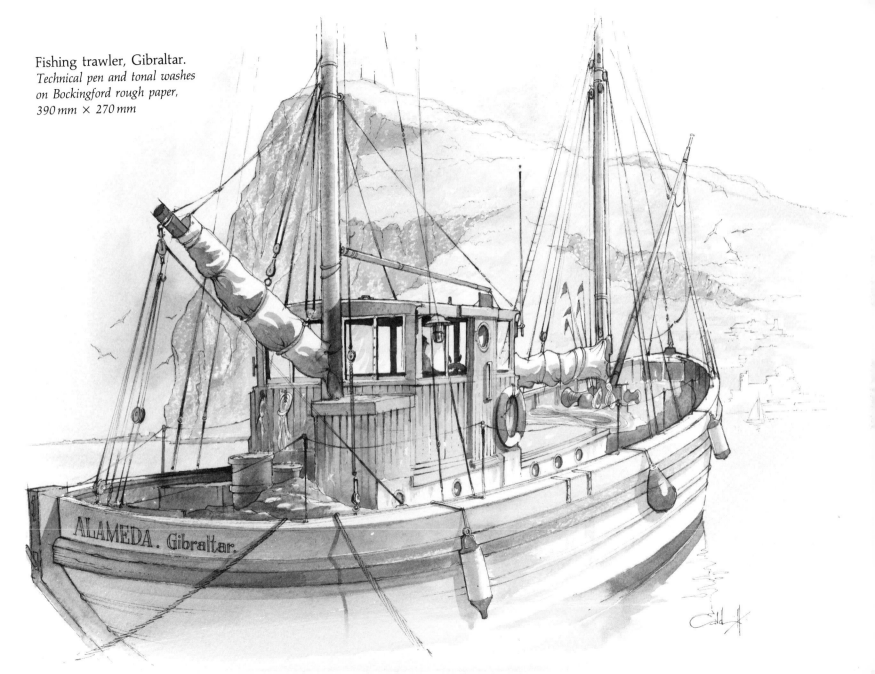

Fishing trawler, Gibraltar.
*Technical pen and tonal washes
on Bockingford rough paper,
390 mm × 270 mm*

ALAMEDA. Gibraltar.

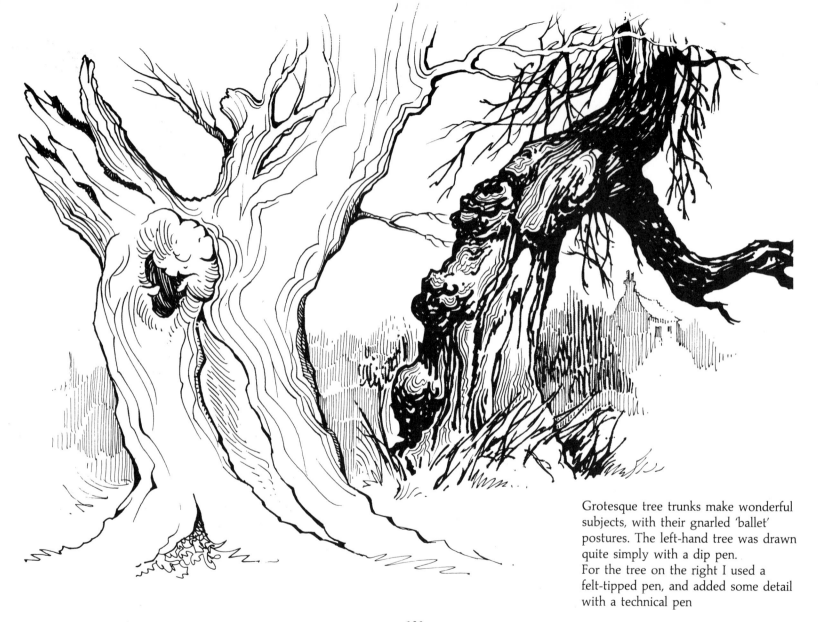

Grotesque tree trunks make wonderful subjects, with their gnarled 'ballet' postures. The left-hand tree was drawn quite simply with a dip pen.

For the tree on the right I used a felt-tipped pen, and added some detail with a technical pen

rein here, given a guide with a few simple but appropriate lines.

The imagination is very revealing when it is allowed the room and scope to operate. A good example would be the mere placing of a distant bird on a completely blank white space, immediately transforming that space into sky. In the case of water, what could be simpler to draw than the little 'squiggle' of the reflection of a boat's mast — the white paper immediately becomes water! I have used these two small, rather mundane examples to show how little one needs to do to achieve a meaningful result.

Water usually flows in a certain direction unless obstructed by rocks, posts or other objects. It will flow around these, joining up again further downstream. All this might sound a rather obvious and child-like explanation, but your linework showing the water's flow should follow a similar course. Even reflections from a bridge should be denoted by lines going in the same direction as the water.

When water is perfectly still, your lines of reflection should be mainly vertical, with a little 'squiggle' now and again for variation. Notice what happens when a seagull first touches the surface

of water. Small circular waves are created, and the seagull's distorted reflection — which is just discernible — follows the same circular pattern as the waves.

In conclusion, and at the risk of repeating myself, remember that you should always try to work on a drawing in the simplest, clearest way, *suggesting* detail rather than filling in every tiny feature.

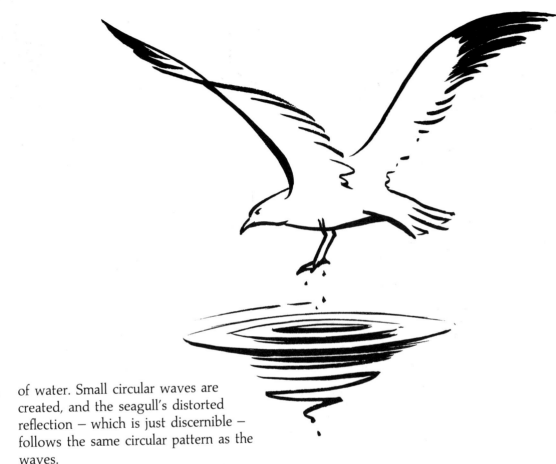

Simple circular marks depict the movement of the water as the seagull touches it

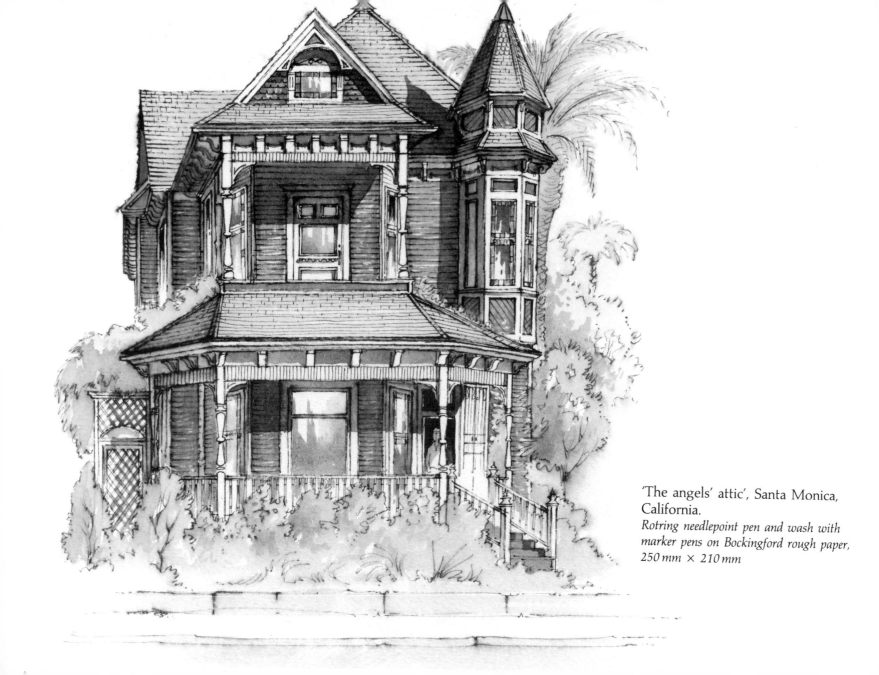

'The angels' attic', Santa Monica,
California.
*Rotring needlepoint pen and wash with
marker pens on Bockingford rough paper,
250 mm × 210 mm*

LINE AND MIXED MEDIA

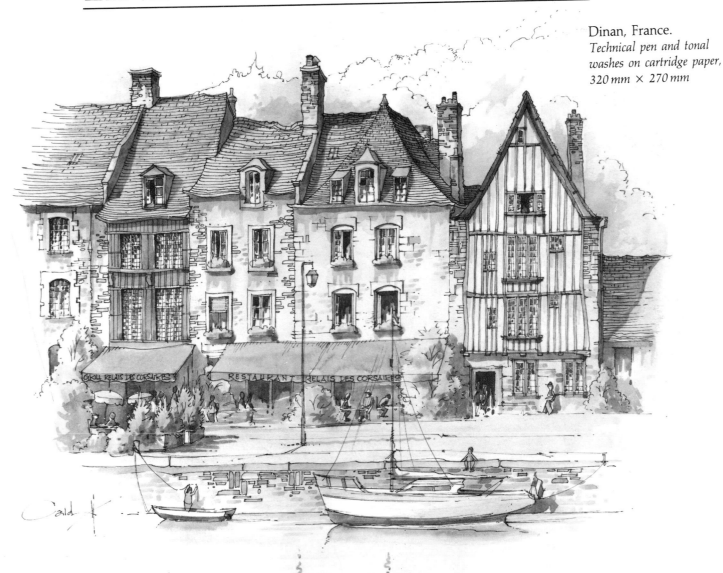

Dinan, France.
*Technical pen and tonal
washes on cartridge paper,
320 mm × 270 mm*

There used to be a time when purists ruled the roost, and whatever they said was regarded as sacrosanct, so that anyone who had the audacity and courage to deviate from the established methods of painting and drawing was looked down upon. Happily for all concerned with art – gallery owners, the viewing public and the artists themselves – things have changed drastically over the years. Almost anything goes in the name of art, and 'rules' are broken to achieve the desired effect. Working sketches, once looked upon merely as the artist's preliminary idea, were invariably shelved or thrown away after serving their purpose. Nowadays, however, they are often held in high esteem and can be very collectable.

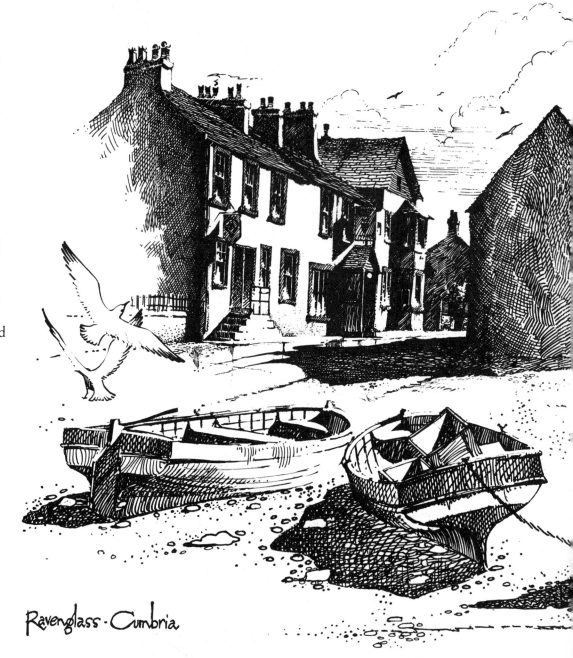

Ravenglass, Cumbria.
Technical-pen drawing on smooth grey paper. Various areas were highlighted with white gouache.
405 mm × 255 mm

Ravenglass · Cumbria

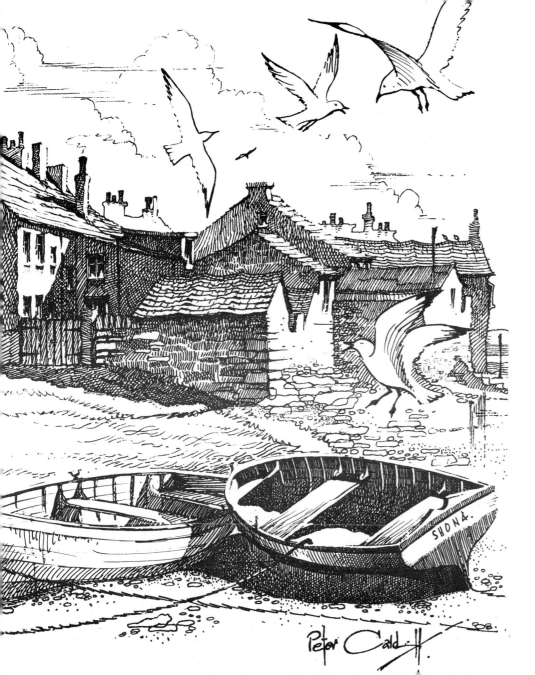

Mixing the various media is also now very acceptable, and some of the results can be extremely pleasing. Combinations may include:

- watercolour and pastel
- pastel with gouache
- marker pens combined with watercolour
- acrylic and oil

The list goes on!

Last, but not least, we can indulge ourselves with:

- line and coloured pencils
- line and pastel
- line and conté crayon

LINE WITH A TONAL WASH

Here you will see a few examples of the effects that may be achieved with line and wash. Some artists carry out the ink drawing first, and then loosely brush over with a tonal or colour wash. Others roughly pencil in the general shapes and areas, and then paint over quite freely before finally using ink to tie the whole composition together. I have used both these methods in my work, and there is something to be said for each.

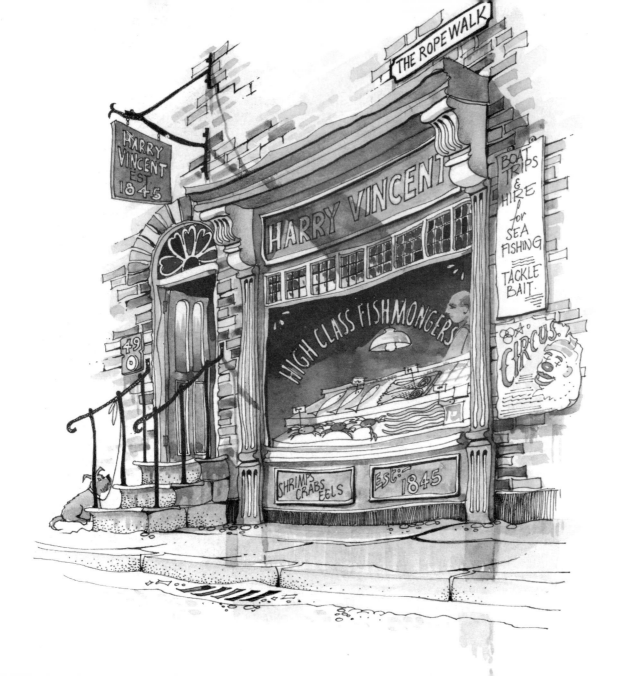

Fishmonger's, Morecambe.
*Technical pen and tonal washes
on smooth cartridge paper,
240 mm × 195 mm
Note: although this was a real
place it had a distinct cartoon
feel to it, so I treated it in
this manner*

Making the line drawing first allows you to see – more or less – the whole finished sketch or picture before you apply the wash. The great danger is that one tends just to 'fill in' the relevant areas, almost like painting by numbers. So the lesson here is to be loose and free with the paint, even if it overlaps or spills into adjacent areas. After all, the charm of a sketch is its spontaneity!

Loosely painting the subject first is good fun, even allowing for the odd accidental splash or run. When it is dry, the picture can then be 'pulled together' with some linework, giving certain indistinct splodges more shape. What the lines do, in fact, is simply to give the picture a little more framework and discipline.

As your observation and drawings improve, try mixing the different media. An otherwise ordinary line drawing will achieve extra dimensions, for instance, if you add grey or a slightly tinted wash with a sable brush.

Old Glossop, Derbyshire.
This was drawn with fibre-tip outline, and then filled in with felt-tipped marker pens. It was executed on rough watercolour board.
375 mm × 275 mm

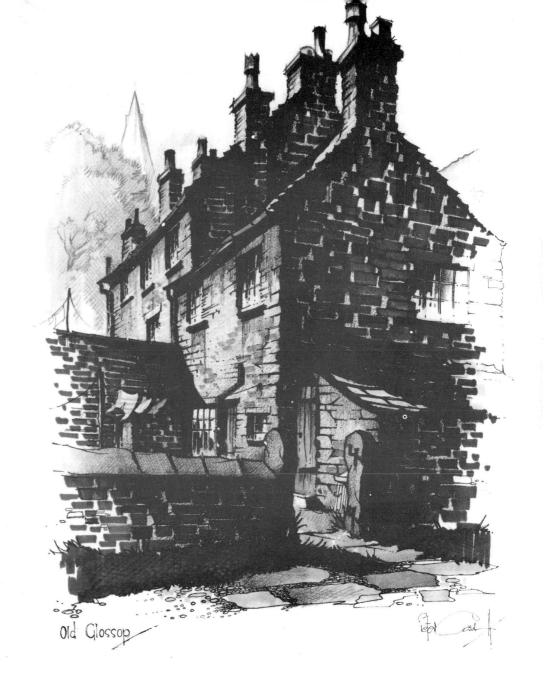

Old Glossop

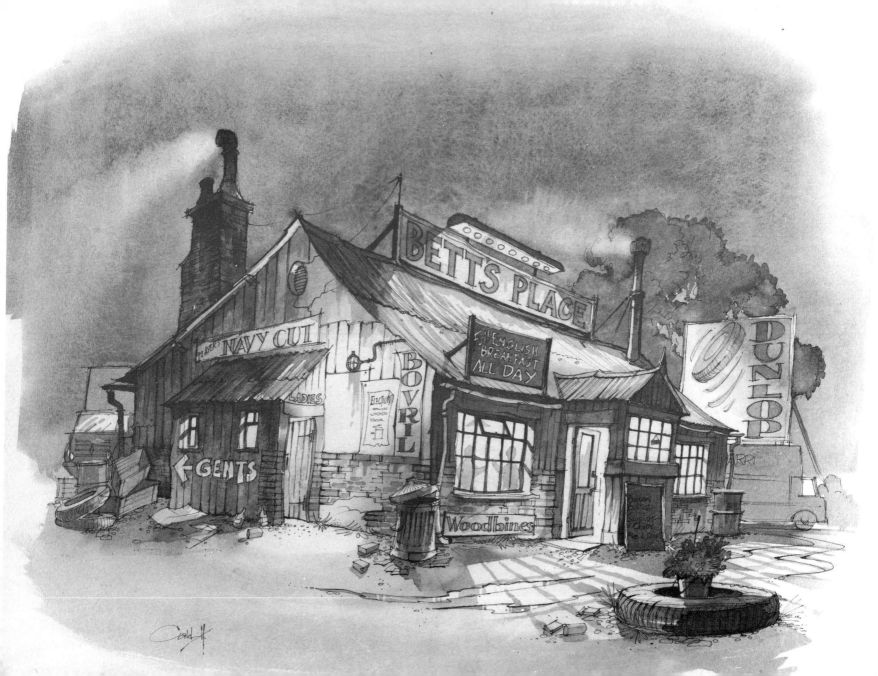

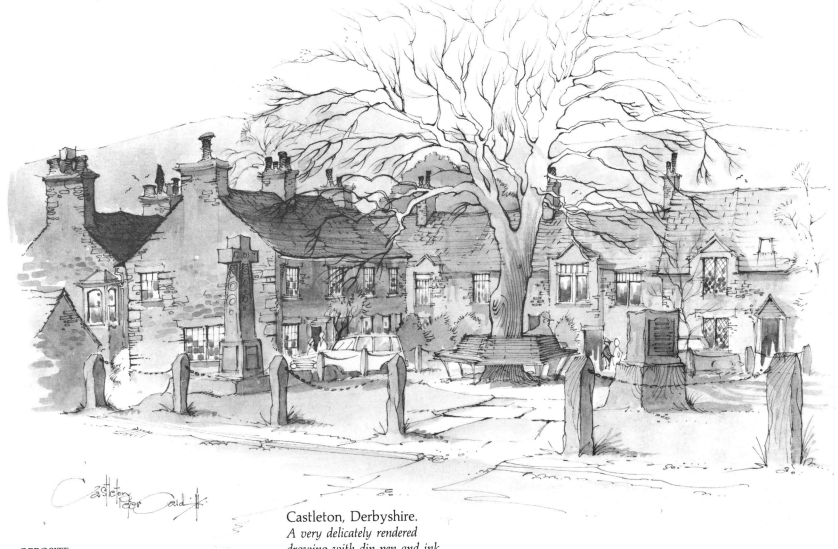

OPPOSITE:

Bett's Place, Great North Road.
*Technical-pen drawing and tonal
washes on Bockingford rough paper,
470 mm × 365 mm*

Castleton, Derbyshire.
*A very delicately rendered
drawing with dip pen and ink.
The wash was also applied
loosely in subdued tones, in
keeping with the area.
355 mm × 250 mm*

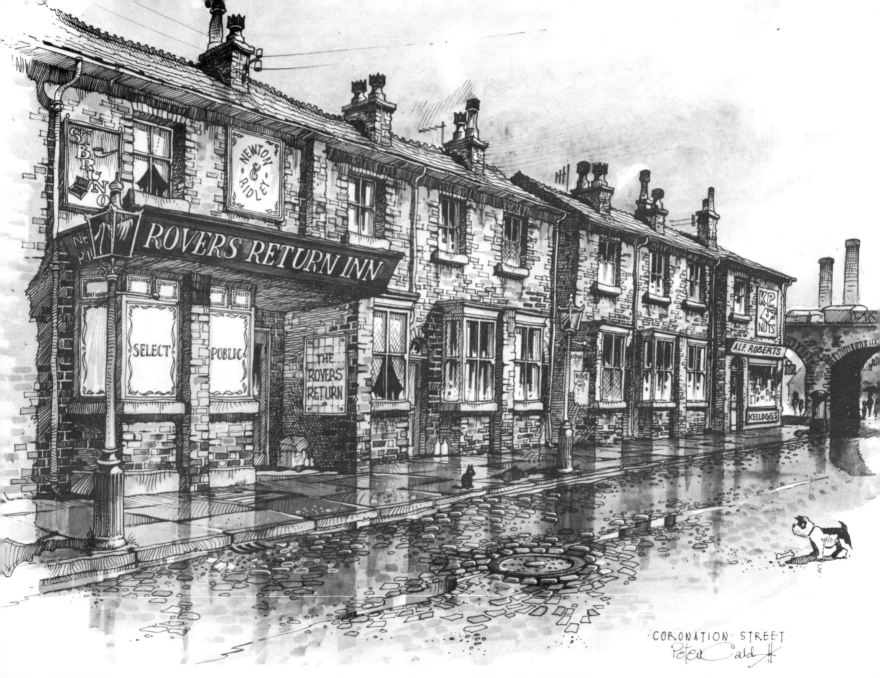

CORONATION·STREET

Peter Cald*

SKETCHBOOK STUDIES

The following pages show a number of drawings of various kinds that I have made over the years, together with comments on the materials used.

OPPOSITE:

Coronation Street.
Fibre-tipped pen with grey, diluted-ink washes on smooth cartridge paper, 455 mm × 340 mm
Note: the reason for this drawing goes back to the early days of the famous television series, when I was one of the Art Directors. The drawing was a 'visual' or concept of how 'The Street' was to look

RIGHT:

A page from my sketchbook showing small details of French life

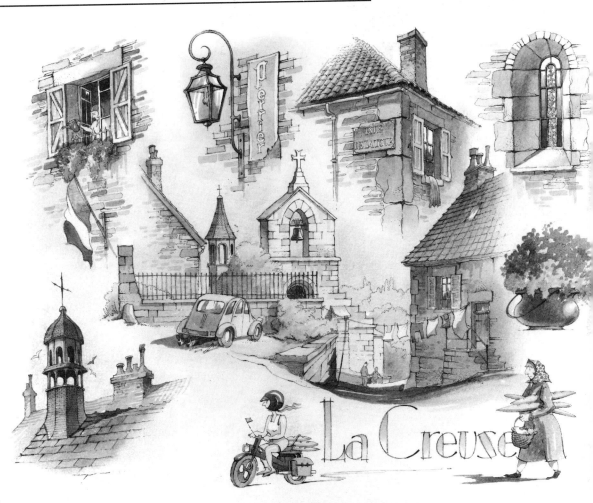

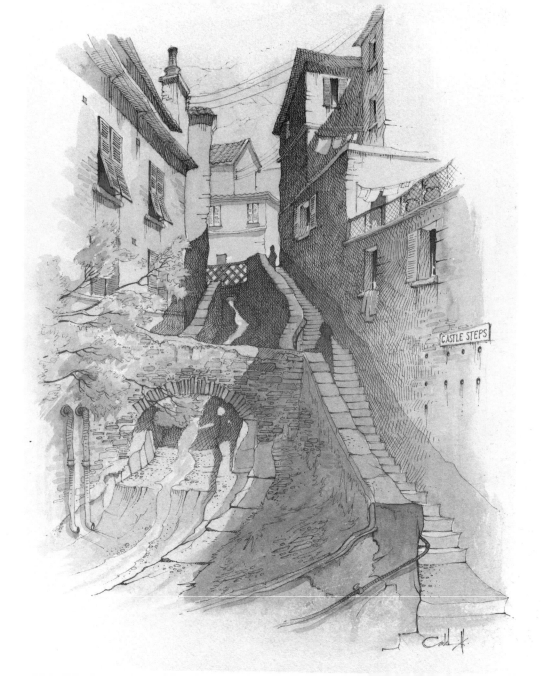

Castle steps, Gibraltar.
*Technical pen and tonal washes
on Bockingford rough paper,
260 mm × 330 mm*

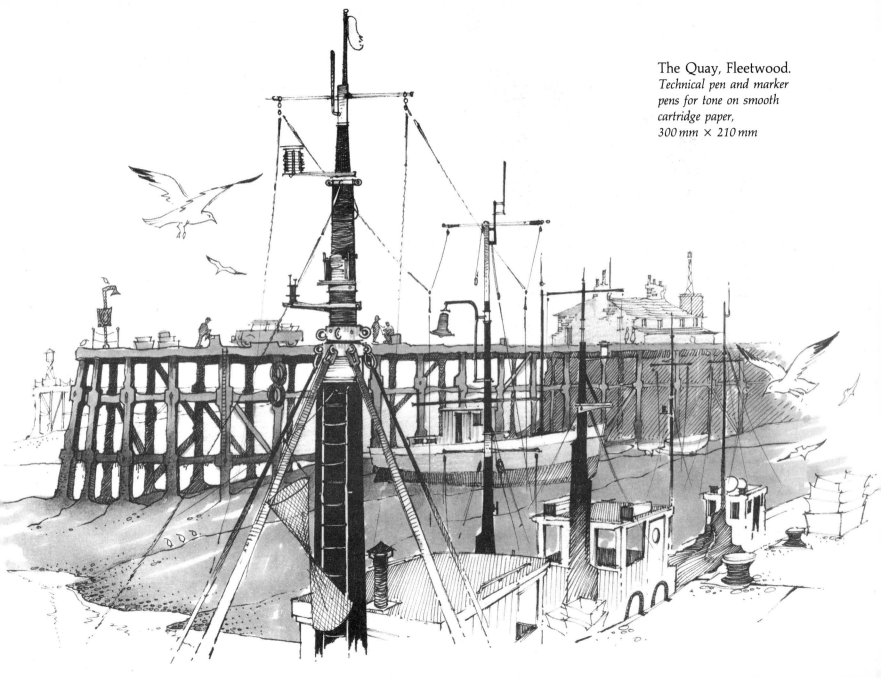

The Quay, Fleetwood.
*Technical pen and marker
pens for tone on smooth
cartridge paper,
300 mm × 210 mm*

Quick sketchbook study
of American Hobo in Santa Monica.
Technical pen on cartridge paper

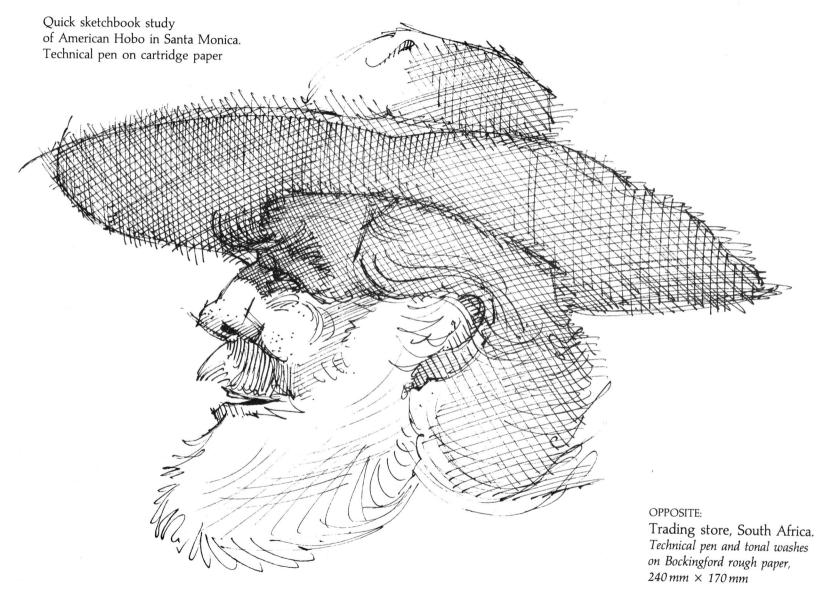

OPPOSITE:
Trading store, South Africa.
Technical pen and tonal washes
on Bockingford rough paper,
240 mm × 170 mm

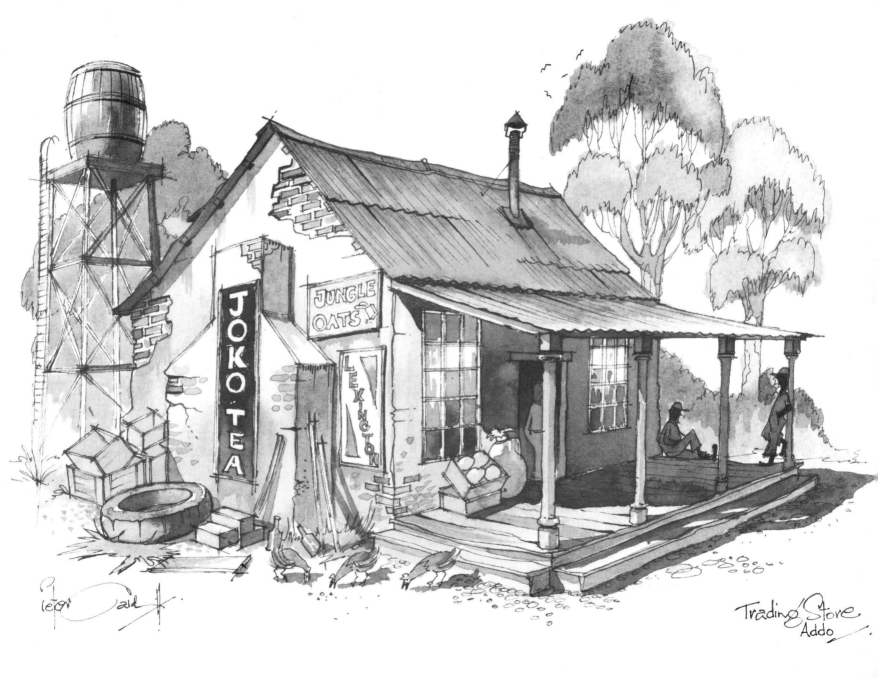

JOKO TEA

JUNGLE OATS

LEXINGTON

Trading Store
Addo

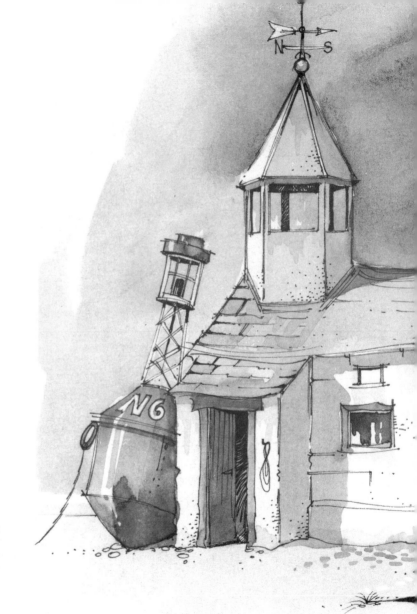

Glasson Dock, Lancashire.
Technical pen and tonal washes
on smooth cartridge paper,
335 mm × 200 mm

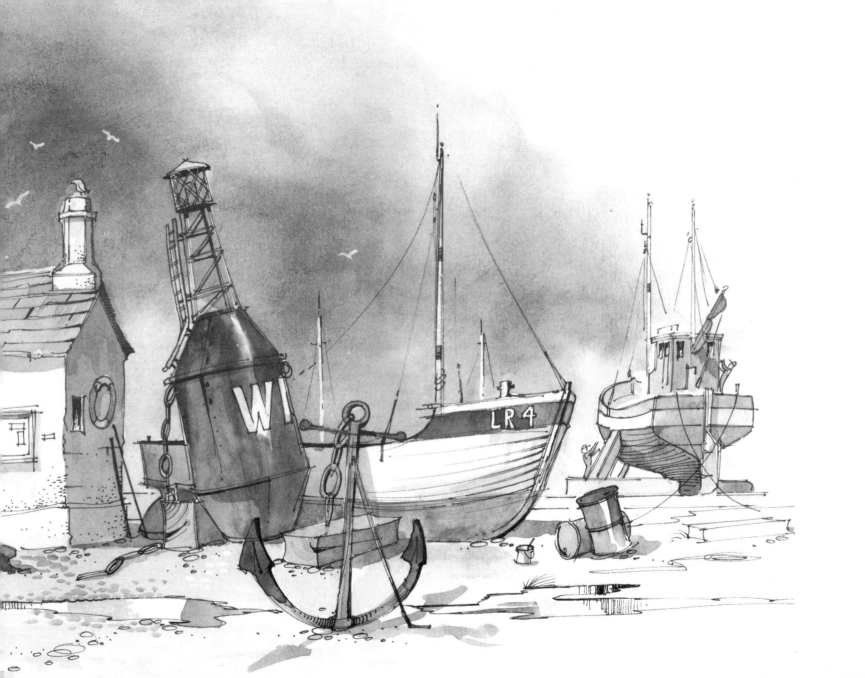

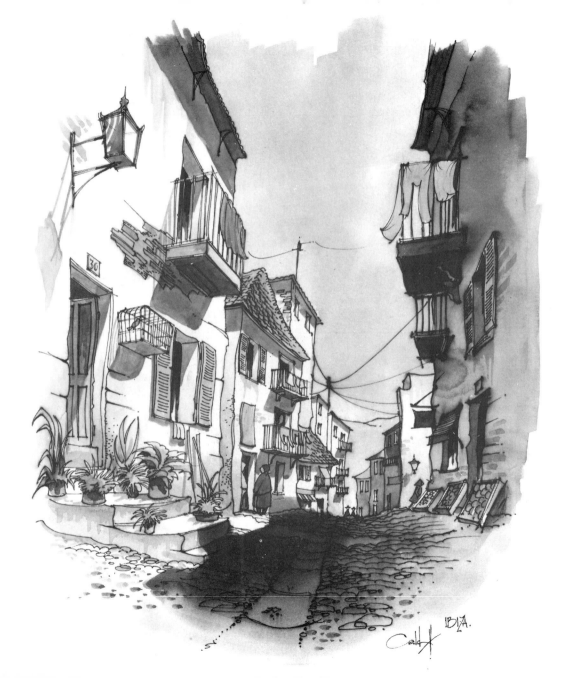

Ibiza, Mediterranean.
*ArtPen and tonal washes
on smooth cartridge paper,
265 mm × 330 mm*

OPPOSITE:
Santa Monica, California.
*Technical pen and tonal washes
on Bockingford rough paper,
300 mm × 260 mm*

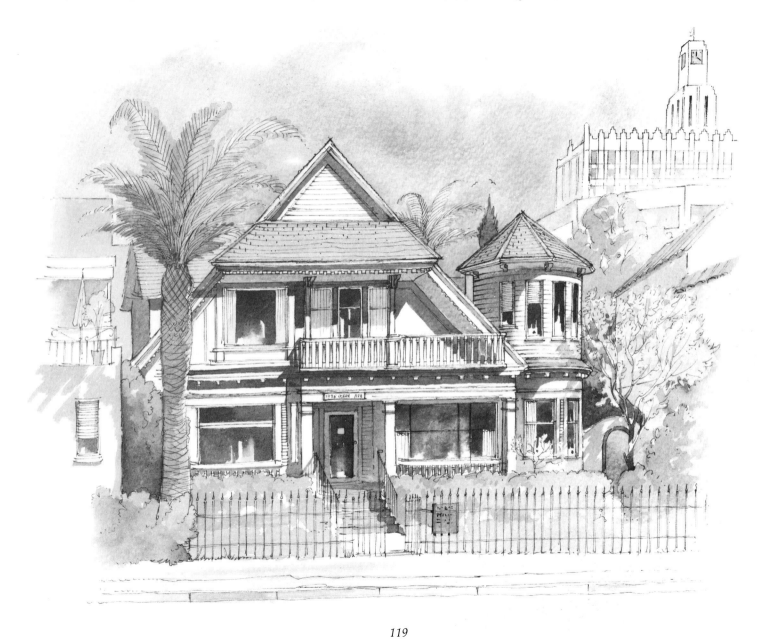

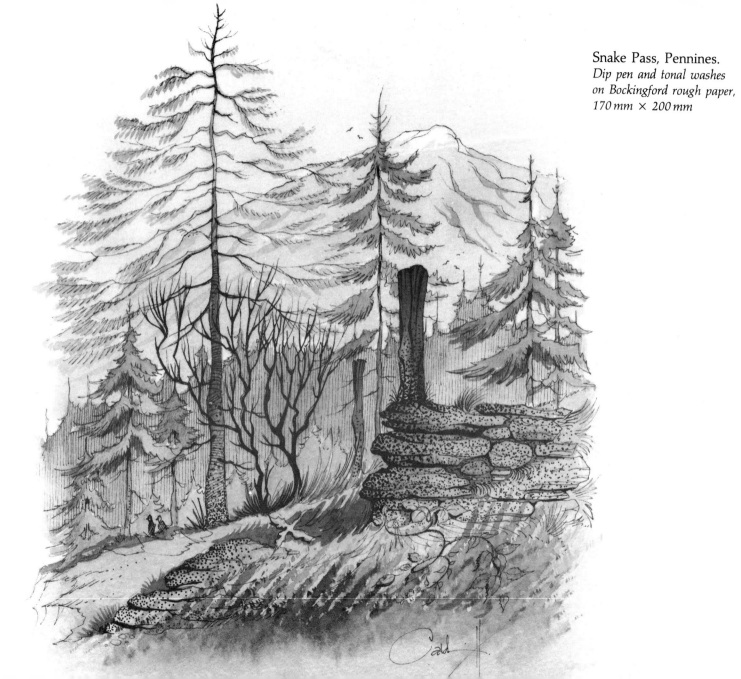

Snake Pass, Pennines.
*Dip pen and tonal washes
on Bockingford rough paper,
170 mm × 200 mm*

CONCLUSION

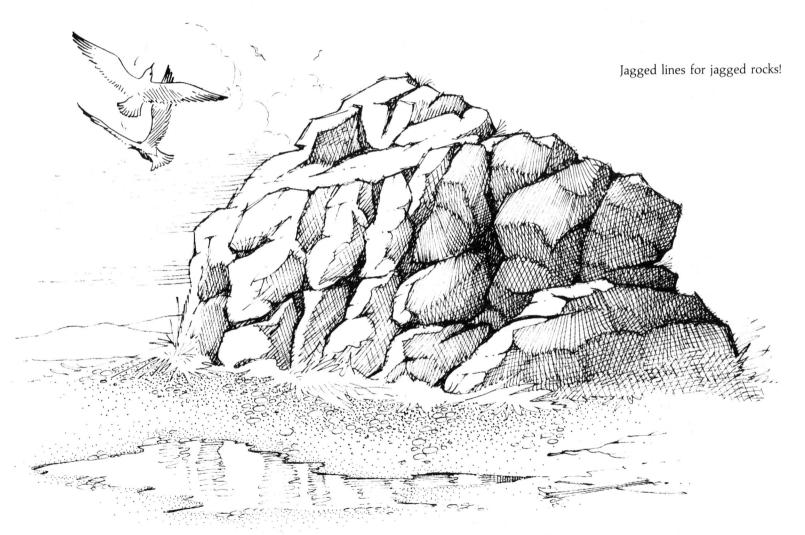

Jagged lines for jagged rocks!

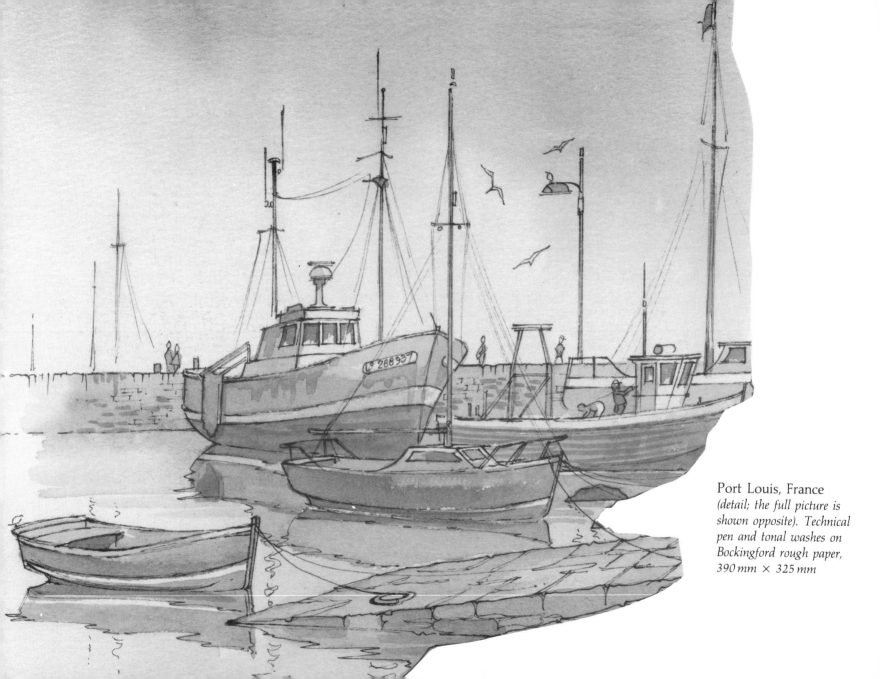

Port Louis, France
(detail; the full picture is shown opposite). Technical pen and tonal washes on Bockingford rough paper, 390 mm × 325 mm

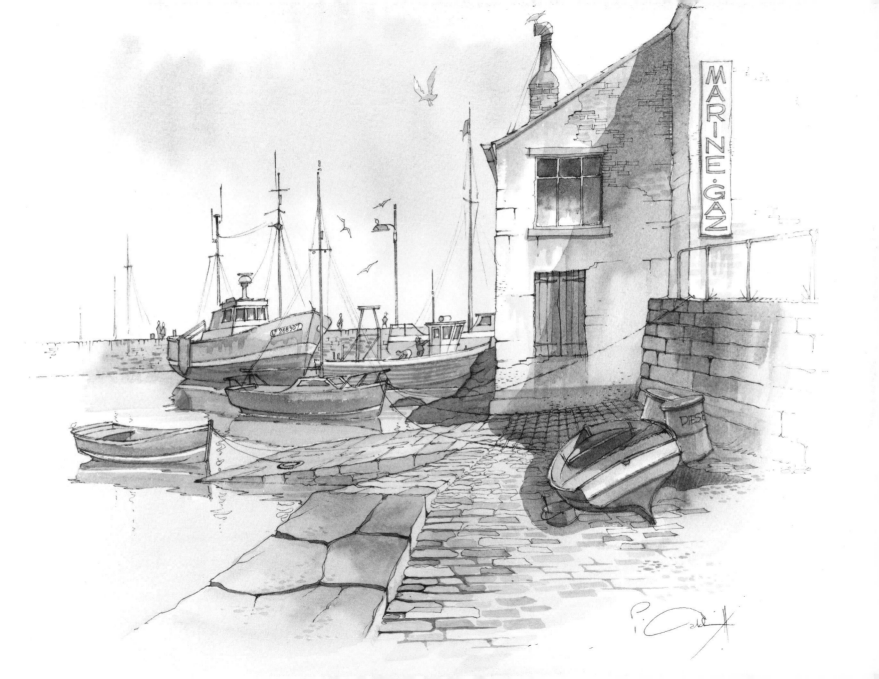

I hope that you have enjoyed and benefited from my personal observations and advice in this book. I will close with a few extra points for you to consider, as well as recapping on a number of worthwhile cautionary notes.

- Most of the drawings in this book have been 'drifted off' into the surrounding blank paper. The technical term for this is *bleeding off* or *vignetting*. I have done this on purpose, and the effect is to lead the eye into the picture. It also gives the drawing a more pleasing finish than if it had been taken right up to the extreme edges of the paper. Drawing and sketching lend themselves particularly well to vignetting.

- The temptation to include too much is a strong one, and it is worth stressing the message again here. Where there is an abundance of detail — as with foliage, sky, slates, woodgrain, pebbles and so on — merely *suggest*. Implied detail provokes the imagination, and this subtle response contributes greatly to the picture's appeal.

- Try to avoid 'dirty' pencil and penwork — keep lines clean and keep your hands off the drawing surface. Grease and dirt will seriously hamper your efforts. Don't scratch away at something you are not sure about. Draw when you are ready to draw, and then be positive about it, even if you know your technique could be better. Uncertainty in a drawing shows, no matter how hard you try to disguise it!

- Beware of a lack of main interest in your work. There must have been something which particularly caught your attention in the first place, and this should be your focal point. Having decided upon this, avoid including anything that leads the eye away from it. On the same theme, it is important not to place two special features some distance apart, as they will compete for attention.

A section of the sketch on page 48, showing how details are merely *suggested*

- Try to draw with lines and textures which are sympathetic to the material of which the object is made. For example, use hard, jagged lines for hard, jagged rocks, and smooth, gentle, broad strokes for smooth, gentle water ripples and reflections. Broken stipple lines are appropriate for a sandy, pebbly beach, and graceful, sweeping lines for seagulls in flight. The message is simple and clear – always draw with feeling!

- Do draw as large as your paper allows, but don't be too ambitious at first. Trying to carry out a picture on a spectacular scale at the start is asking for trouble. It is infinitely better to draw a flower or small boat really well than a gigantic, but rather insipid, impression of the whole of San Francisco! When you can draw small subjects confidently, then you can raise your sights to more distant horizons.

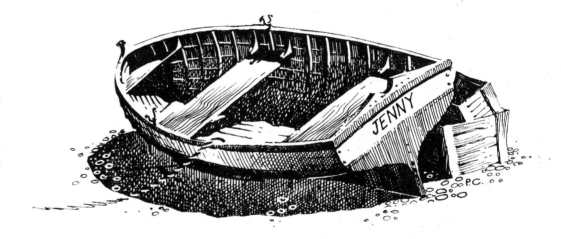

Remember that it is always better to draw well on a small scale than to over-stretch yourself

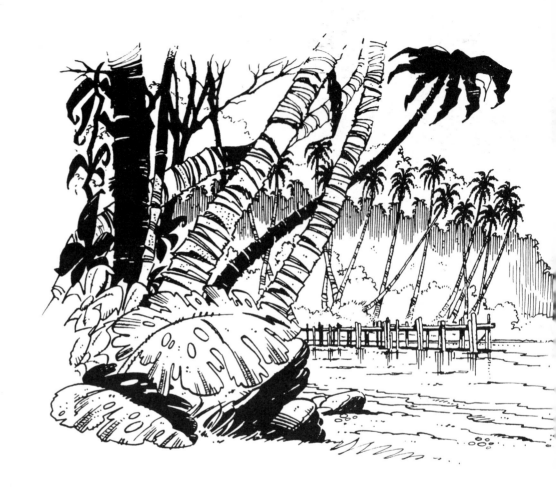

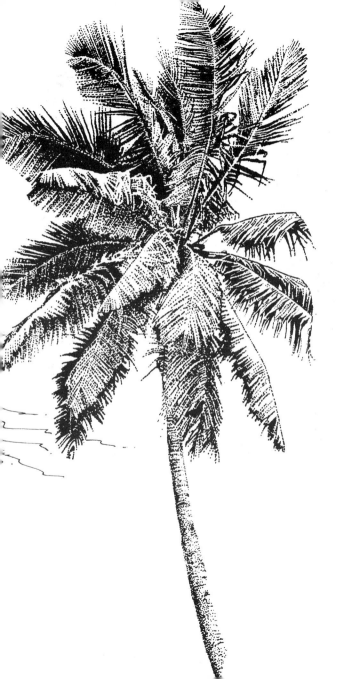

Mahé, Seychelle Islands.
A page from my desert-island sketchbook.
The trees and foliage on the left were drawn
with a dip pen; the single palm tree with a
technical pen using 'stippling', a method
of using dots to build up shapes and shading.
Although rather time-consuming, the finished
effect is softer than conventional linework.
Sketchbook-page size 260 mm × 190 mm

127

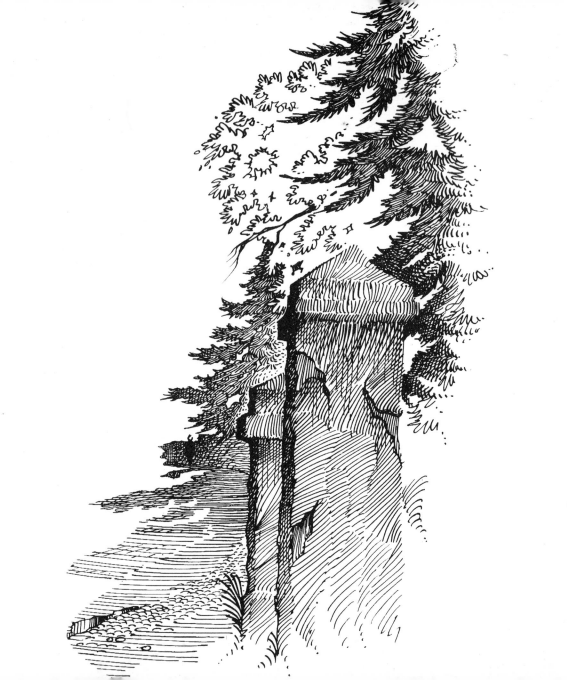